HANDBOOKS

FRENCH IMPRESSIONISTS

handbook presents a selection of sixty-four of the Fitzwilliam
um's finest paintings and drawings by French Impressionist
ers. It includes paintings by Monet, Renoir, Sisley, Pissarro,
me, Boudin and Seurat which are widely considered to be among
painters' greatest works, as well as other lesser-known works by
in and Signac, and several which are published here for the first
Degas features prominently in the book, with a particularly splen-
oup of watercolours, pastels, drawings and paintings, many of
..m early works. The introduction gives a lively account of what an
'T· ssionist' painter was – and came to mean – and also explains
how these works came to be in Cambridge collections,
against a background of developing taste for
Impressionist painting in Britain.

FRENCH IMPRESSIONISTS

JANE MUNRO

SENIOR ASSISTANT KEEPER OF PAINTINGS, DRAWINGS

AND PRINTS, FITZWILLIAM MUSEUM

PHOTOGRAPHY BY ANDREW NORMAN

AND ANDREW MORRIS

CAMBRIDGE
UNIVERSITY PRESS

PUBLISHED BY THE PRESS SYNDICATE OF THE UNIVERSITY OF CAMBRIDGE
The Pitt Building, Trumpington Street, Cambridge, United Kingdom

CAMBRIDGE UNIVERSITY PRESS
The Edinburgh Building, Cambridge, CB2 2RU, UK
40 West 20th Street, New York, NY 10011–4211, USA
477 Williamstown Road, Port Melbourne, VIC 3207, Australia
Ruiz de Alarcón 13, 28014 Madrid, Spain
Dock House, The Waterfront, Cape Town 8001, South Africa

http://www.cambridge.org

First published 2003

Printed in the United Kingdom at the University Press, Cambridge

Typeface Quadraat Regular 9.5/13.75 pt. System LaTeX 2ε [TB]

A catalogue record for this book is available from the British Library

Library of Congress Cataloguing in Publication data
Munro, Jane.
French impressionists / Jane Munro.
p. cm. – (Fitzwilliam Museum handbooks)
Includes bibliographical references and index.
ISBN 0 521 81326 3 (hardback) – ISBN 0 521 01281 3 (paperback)
1. Impressionism (Art) – France – Catalogues. 2. Art French – 19th century – Catalogues.
3. Art England – Cambridge – Catalogues. 4. Fitzwilliam Museum – Catalogues. I. Title. II. Series.
N6847.5.I4M86 2003
759.4′09′03407442659 – dc21 2003043944

ISBN 0 521 81326 3 hardback
ISBN 0 521 01281 3 paperback

CONTENTS

ACKNOWLEDGEMENTS

A volume such as this is weighty only in its debt to the scholars, archives and libraries that have played a part in its compilation. The bibliography is stringently selective; I fully acknowledge a far wider debt to scholars in the field who have, notably in the last decade, contributed enormously to our understanding of the subject, and of the work of the individual Impressionist painters.

The Provost and Fellows of King's College have generously given permission for works from the Keynes collection to be included in this book; their public-spiritedness ensures that these works continue to be made available to the public through display at the Fitzwilliam. The Master and Fellows of Trinity College have kindly accorded permission to quote from the Andrew Gow Papers, which have informed much of the section devoted to this collector in the introduction.

I have benefited from the help, knowledge and advice of a number of friends and colleagues, the list that follows being as select as the bibliography: Sandrik Anson, Katherine Baetjer, Emmanuelle Brugerolles, Françoise Cachin, Dawson Carr, Anne Distel, Marina Ferretti-Bocquillon, David Guillet, Richard Kendall, Ian McClure, Richard Shone, Thyrza Smith, MaryAnne Stevens, Katey Stoner. The staff of the Bibliothèque Nationale de France, the Bibliothèque du Louvre, the Documentation of the Musée d'Orsay, the British Library and the Witt Library have helped with a number of enquiries. The inépuisable équipe at the Bibliothèque d'Art et Archéologie Jacques Doucet deserves special recognition for unfailing helpfulness and – rarer still – consistent good humour.

The supportiveness of my immediate colleagues in the Department of Paintings, Drawings and Prints made it possible for me to carry out much of the research during an extended period of study leave. I thank them, the director, Duncan Robinson, and the Syndics of the Museum for granting this time to carry out the necessary research. Andrew Norman and Andrew Morris once again ensured the extremely high quality of the reproductions. My thanks to Caroline Bundy, who saw through the publication of the volume with the lightest of editorial touches.

NOTE ON SOURCES

This handbook is designed for general readership; for this reason in-text references have been kept to a minimum.

The introduction owes much to Douglas Cooper's and John House's accounts of Samuel Courtauld's collecting, and to the sourcebook edited by Kate Flint (see selected reading, below). Ruth Berson's volume detailing the critical reception of Impressionist exhibitions contains much useful information about the evolving dynamics between the group and the conditions of exhibition. Archival sources at the Fitzwilliam Museum have helped to elucidate the formation of the collection at Cambridge; the reader is directed specifically to Fitzwilliam Museum Archives nos. 000264, 000505, 000630, 000631, 000652, 000653, 000708, 000858, 001161, 002169, 002640 and the Gow-Lesmoisne correspondence, Department of Paintings, Drawing and Prints. At Trinity College, Cambridge, the Gow Papers, specifically AI/I1 (23) have helped to reconstruct the purchases and personality of Andrew Gow, whose bequest of works by Degas in particular did much to enhance the museum's holdings of Impressionist works.

Theodore Reff's catalogue of the *Notebooks of Edgar Degas* has provided information that has been key to the understanding and dating of several works by Degas. These are abbreviated in the text; the fuller references to the notebooks and pages, preceded by the handbook number are: no. 21: notebook 3, pp. 72, 45; no. 22: notebook 16, p. 8; no. 23: notebook, 7, pp. 7 and 19; no. 28: notebook 14A, fo. 599v; no. 30: notebook 25, pp. 3, 5; no. 31: notebook 32, p. 3B; no. 40: notebook 23, p. 45. Details about the sale of the Beaucousin paintings (no. 28), and specifically Beaucousin's reluctance to part with his paintings, are drawn from the National Gallery Minutes of Board Meetings, 4.114, November 1857, in the National Gallery, London.

A list of references and further reading can be found at the end of the book.

INTRODUCTION

'I do not wish to foresee what the future
will hold for the artists of rue Peletier; will
they one day be considered great masters?'

Fortunately for his posthumous reputation, the critic Arthur Baignères answered his own question in the affirmative. Although he was by no means an unqualified admirer of the Impressionists, his judgement of the painters whose works he reviewed at their second group exhibition in April 1876 – albeit tempered by a certain cynicism – accurately forecast the esteem in which their works would come to be held.

Some of the exhibiting painters became acknowledged masters little more than a decade after Baignères's review. By 1889, Monet was being hailed as one of the greatest painters of all time, and – like Renoir – was offered (but refused) the Légion d'Honneur a year or so later. By the end of the 1890s, the slightest scrap of a drawing by Degas was selling for 'fabulous' sums, while Monet's annual income from the sale of paintings not infrequently exceeded an impressive 200,000 francs; as he later told the writer Wynford Dewhurst, the tide of his fortunes had turned after the sale of the collection of Victor Chocquet in 1899, when dealers began to make the pilgrimage to Giverny to buy up even those canvases he had rejected: 'Today [c. 1904] I cannot paint enough, and can probably make fifteen thousand pounds a year; twenty years ago I was starving.' Public recognition of a different sort came in the same decade, when works by Impressionist painters began to enter museums in France and abroad. Alfred Sisley's *September Morning* (Musée des Beaux-Arts, Agen), painted around 1887, was acquired the following year by the Ministry of Fine Arts, and in 1892 Renoir received an official commission to paint *Young Girls at a Piano* for the Luxembourg Museum, the state museum for modern art. The most important development in this respect took place in 1894, however, when the French state accepted – not without opposition – paintings by Renoir, Degas, Cézanne, Monet, Pissarro, Morisot and Sisley, which had been bequeathed to the nation by the Impressionist painter, Gustave Caillebotte; thanks to his gesture, the majority of these painters, at least, were able to see their still-controversial works displayed in a national institution in their own lifetime.

In the course of the twentieth century the private passions of individuals gradually made their way into the public arena through the gift, bequest or sale of their collections of Impressionist works to museums and galleries in Europe, the United States and the Far East. From these, they have been reconstituted into virtual galleries and exhibitions, which can be 'visited' through the Internet by global audiences on a scale that contemporary critics would have found unimaginable (and, in Baignères's case, no doubt abhorred). As a result,

the Impressionist painters have, in little over a century, attained a level of popularity that in some cases borders on cult status, while the energetic marketing of their imagery has bred a familiarity which, it has been argued, makes it more difficult than ever to appreciate fully the radicalism of this 'new painting'.

The scope of this handbook is at once defined and enriched by the holdings of a single collection, created in less than a century by gift, bequest and occasional purchase, and which, to a great extent, reflects the tastes and ambitions of the individuals who have helped to form it. The specific strengths of the collection arise in part from the personal preferences of those collectors who have given or bequeathed works, but also from the cumulative acquisition of chronologically or thematically related works. Notable in this last respect are pairs of paintings that show Pissarro's extraordinary skill as a painter of snow (nos. 43, 45), Monet's as a painter of sea (nos. 9, 10), and two contrasting views of Brittany by Renoir and Monet, both painted in 1886, the year which saw the last group exhibition of the Impressionists' work (nos. 10, 17). The Museum owes its exceptional holdings of Degas drawings – reflected in their preponderance in this handbook – to one individual, Andrew Gow, whose bequest in 1978, rich, notably, in the artist's early works, transformed the collection. Happily, this core has been enhanced in recent years by a magnificent group of wax sculptures, given by the late Paul Mellon, KBE, and his wife in honour of Michael Jaffé, one of the Museum's most distinguished directors, and by the acquisition in 2000 of a rare and exceptionally beautiful early landscape, painted during Degas's first visit to Italy in 1856 (no. 24).

WHO WERE THE IMPRESSIONISTS?

Defining an Impressionist painter is fraught with difficulties. The paintings and drawings included in this handbook were produced by only a few of the artists who exhibited at one, or more, of the eight group exhibitions between 1874 and 1886, which were subsequently – if almost always controversially – termed *Impressionist*. This deceptively straightforward rationale allows for the inclusion not only of those artists who quickly became identified by the writer and critic Théodore Duret as the 'primordial' Impressionists – Pissarro, Monet, Sisley and Renoir – but also of lesser-known painters such as Adolphe-Félix Cals (no. 1), who, although arguably more closely related to the realist painters of the Hague School, in fact showed more consistently at the group exhibitions than many of its perceived leaders.

As is now well known, the group of thirty artists who formed themselves into a body to exhibit 165 works in the former premises of the photographer Nadar in the boulevard des Capucines in 1874, initially settled on the wordy, if inoffensive, catch-all title of 'The Anonymous and Cooperative Society of Artists, Painters, Sculptors and Engravers, etc.' (neatly abbreviated by Cézanne to the Coop. Society). Many of the original group – Monet, Cézanne, Pissarro, Renoir and Sisley – had been fellow-students in the 1860s, and trained either in the Atelier Suisse (see no. 52) or in the studio of another Swiss painter, Charles Gleyre. Renoir later

remembered that they came together mainly in response to their 'mutual poverty', although a core group of acquaintances also shared specific artistic objectives, defined by the writer Jules Castagnary in a review of their first exhibition as the desire to paint, 'not the landscape but the sensation produced by the landscape'.

At their first exhibition in 1874, the exhibitors were communally branded the 'Impressionists' by the critic Louis Leroy, in an instantly infectious neologism coined in satirical response to Monet's painting, 'Le Havre, *Impression: sunrise*' (Musée Marmottan, Paris), so called, the artist claimed, because he couldn't hope to pass it off as a view of the port it nominally represented. The lack of finish and banality of the subjects that critics perceived in this and other paintings justified the worst fears of those who for some years had been voicing concerns about the direction of the modern school of French landscape painting. Only a decade earlier, for example, the critic Léon Lagrange, while praising the achievement of contemporary painters in liberating nature from the artificial constructs of the 'historical landscape' (*paysage historique*), recognized that the very simplicity of the naturalist approach was likely to bring about an exaggerated emphasis on novelty of technical expression, and an undue preoccupation with the material fabric of their art.

Given these prognostications, and the frequency of the term *impression* in contemporary artistic and critical vocabulary, it is not surprising that Leroy's appellation quickly gained currency. The Impressionist painters themselves, on the other hand, did not adopt the term until their third group exhibition in 1877, when it appeared in an associated promotional document, *Impressioniste. Journal d'Art*. Thereafter, the term *impressioniste*, when not entirely rejected in the case of exhibitors such as Albert Lebourg, Henri Rouart and Jean-François Raffaëlli, was constantly qualified to sift out the 'real' Impressionists from the 'half' Impressionists, the 'old' Impressionists from the 'new' Impressionists and – partially related to the last – the 'romantic' from the 'scientific' Impressionists, the latter referring to neo-Impressionist painters such as Seurat, Signac and Guillaumin, who showed at the final group exhibition in 1886. The highly literate Degas – whose unilateral decision to expand the group's membership in 1879 created considerable friction among the original participants – made particularly strenuous efforts to evolve a more appropriately inclusive term to describe their multifarious styles and objectives, and proposed that they adopt the title 'Impressionist, Realist and Independent' painters for their exhibition that year. In the event, however, only the last term was adopted, and many critics perceived the change simply as 'old wine in new bottles'. The artists themselves reacted more violently. Renoir and Sisley refused to show at the exhibition that year, and, with Monet, defected to the Salon in 1880, in protest not only against the change in the group's title but also at Degas's new recruits, whose interests they considered to be remote from their own. In an interview that year, Monet declared that he was, and would always remain, an Impressionist, complaining that the 'little church' he and his colleagues had founded only a few years earlier had been desecrated by these newcomers. For his part, Renoir refused 'at his age' to exhibit as an 'Independent Artist', chary of the

political motivation of the 'anarchist' Pissarro; besides, as he told his dealer Durand-Ruel, it was likely to have a deleterious effect on sales, as 'people do not like it to stink of politics' (in fact, Renoir, like Monet, was keen to pursue alternative marketing strategies through one-man exhibitions in Parisian dealers' galleries). By the last exhibition in 1886, which was dominated by the neo-Impressionist works of Pissarro, Signac, Guillaumin and Seurat (see no. 60), the posters and catalogues announced only the names of the artists, and the term 'independent' was dropped, so as to avoid confusion with a separate group that had been established under the same name two years earlier. Despite these endeavours, critics of the final exhibition clung more tenaciously than ever to the term *impressioniste*, most accepting, though not always restating, the lack of unity of purpose it had come to imply; the few who continued to examine their highly diverse objectives more analytically came to conclude that its philosophy was essentially that of 'a school of abstraction'. For those painters who were able to take a more distanced view, Impressionism became, simply, synonymous with the avant-garde. As such, its badge was to be worn with pride: as Gauguin wrote to his friend Émile Bernard, 'I am an Impressionist artist, that is to say, a rebel.'

COURTSHIP, CONTROVERSY AND COLLABORATION: COLLECTING IMPRESSIONISTS FOR CAMBRIDGE

In his essay, 'La Nouvelle peinture' (The new painting) of 1876, Edmond Duranty anticipated the difficulty that the recently formed group of painters – whom he at no point calls the 'Impressionists' – would experience in gaining public and critical acceptance. He reconciled himself in part to the incomprehension of his compatriots by his conviction that they would be likely to receive a more favourable reception abroad: 'No one is a prophet in his own country', he wrote, 'that is why our painters are far more appreciated in England and Belgium, lands of independent spirit, where no one is offended at the sight of people breaking the rules, and where they neither have, nor create, academic canons. In these countries, the present efforts of our friends to break the barrier that imprisons art . . . seem straightforward and worthy of praise.'

This generous view of English liberal-mindedness was sadly exaggerated. During the key years of Impressionism, and, indeed, for most of the remainder of the nineteenth century, only a very small group of collectors of Impressionist paintings emerged, and the reception of Impressionist painting in Britain was sufficiently low-key for D. S. MacColl, critic of the *Saturday Review*, to complain in 1901 that 'Monet is more familiar in American backwood towns than here.'

American collectors certainly led the way in the acquisition of Impressionist works at the turn of the century, provoking dire warnings from some proselytizing critics that England would end up paying dearly in the future for its neglect of modern French art. One of these, the writer and critic Frank Rutter, took it upon himself to remedy the situation,

launching a vigorous campaign in 1905 to have a work by an artist of the 'luminiferous movement' accepted by the National Gallery. His efforts – later recounted in some detail (and not a little vainglory) in his book *Art in My Time* – were hampered not only by a distinct lack of enthusiasm on the part of the National Gallery, but also by its constitutional inability to accept works by living painters, which at the time excluded Monet, Renoir and Degas, although Pissarro and Sisley were, as Rutter put it, 'safely dead'. In the event, with funds raised privately through special exhibitions and lectures, a late view of the entrance into Trouville harbour by Boudin – whom Rutter considered as a polite precursor of the Impressionists – was presented to the gallery by a group of subscribers in 1906, through the recently formed National Art Collections Fund. In 1913 a further group of Impressionist paintings was lent to the gallery by the Irishman, Hugh Lane, who had been collecting enthusiastically from 1905, when a large – but on the whole unsuccessful – exhibition of their works was held at the Grafton Galleries in London. Even then, however, less than a third of his paintings were exhibited until 1917, two years after Lane's tragic death on the *Lusitania*, when the full collection was put on display in the new Foreign Galleries at the Tate, in a tactical shift of policy designed in part to counter the threat of their return to Ireland under the terms of Lane's disputed will. The following year proved crucial both for the national collections, and, in the longer term, for the presence of post-Impressionist works in Cambridge. Thanks to the intervention of the economist, John Maynard Keynes, the Treasury authorized the National Gallery's director, Sir Charles Holmes, to spend up to £20,000 on paintings at Degas's studio sale in Paris in 1918, one of which was a flower piece by the Impressionist-turned-Symbolist, Gauguin.

For Cambridge, the active role Keynes played in events was of lasting importance, more in his capacity as private collector than as government advisor. For it was at this sale that he acquired, after the National Gallery declined to buy it, a remarkable still life of apples by Cézanne (no. 55). Keynes's appreciation of Cézanne's work at this date was certainly advanced, and undoubtedly cultivated by his friendship with Roger Fry, who became the artist's main champion in England from around 1910. He eventually added a further seven or eight works by Cézanne to his collection and developed a particular appreciation of what Fry termed the artist's 'spunky handling' (see nos. 53, 54). These paintings, along with Seurat's study for the *Grande Jatte* (no. 60), were bequeathed with the rest of his collection to King's College, Cambridge, after his death in 1946.

The decade following the Degas sale proved a turning point for the acquisition of Impressionist painting in Britain, and it was during these years, too, that the foundations of the Fitzwilliam's collection were laid. In 1924 the most remarkable collection of Impressionist works in England – with important groups of works by Cézanne and Monet – belonged to two Welsh sisters, Gwendoline and Margaret Davies, who eventually bequeathed them to the National Gallery of Wales in Cardiff. However, their collection was soon overshadowed by that of the textile manufacturer Samuel Courtauld, who collected intensively between 1922 and 1929, and in 1932 gave to the nation his house in Portman Square, along with a very

significant part of his collection of French paintings. Courtauld's particular significance lay in his commitment to the public domain, demonstrated not only by the gift of his own collection, but also by his creation in 1923 of a fund of £50,000 to enable the Tate to acquire modern foreign art, with potential purchases limited to a list of specified French artists. In a less direct way, the Fitzwilliam has also come to count itself among the beneficiaries of Courtauld's collecting instincts, through the acquisition, in 1986, of a key work of Renoir's Impressionist years, *Place Clichy* (no. 16), one of the comparatively small number of Courtauld's paintings to remain in his possession until his death. It eventually passed to his grand-daughter, who sold it to the Museum at an extraordinarily advantageous *prix d'ami*.

During these same years, two individuals, Frank Hindley Smith and Captain Stanley William Sykes, began to form collections, which, by gift and eventual bequest would transform the Fitzwilliam's holdings of French paintings and drawings. Neither had Courtauld's means at their disposal, but they were nevertheless able to acquire works by Renoir, Degas, Sisley, Pissarro and Monet that are today considered to be among these artists' finest works.

A retired textile manufacturer from Lancashire, Hindley Smith appears to have had no specific connections with Cambridge, although he did have a number of links with Courtauld. In 1926, with Courtauld, Maynard Keynes and Lee Myers he became one the backers of the London Artists' Association – a charitable organization with cooperative aspirations not dissimilar to those of the original Impressionists – and like him, too, took advice in building up his collection from the collector and dealer Percy Moore Turner, whom he eventually made an executor of his will. Turner, who had owned a gallery in Paris, moved to England after the outbreak of the war in 1914 and opened the Independent Gallery in London. He was one of many dealers eagerly buying works by Degas at the sale of his studio in wartime Paris, one of which – *At the Café* (no. 33) – Hindley Smith acquired in 1925. Little is known of Smith's life, although the Bloomsbury painter Duncan Grant, who visited him after he moved to Sussex towards the end of his life, described him as 'A rich man according to our standards . . . without any pretension, simple and charming'; Roger Fry, he wrote, had 'discovered' him, probably around 1920, 'already deep in Proust, well-read, with an acquaintance of painting which he was eager to cultivate'.

Smith's bequest in 1939 of eighteen paintings, nine watercolours and two bronze sculptures to the Fitzwilliam was widely welcomed, not least by one of the Museum's Syndics, Andrew Gow (see below, p. 9). The 'plums' of the bequest, he wrote, were the paintings by Degas and Renoir (nos. 33 and 15); however, as he perceptively observed, the real significance of the bequest lay in establishing a framework for future donations:

> Most of us had been praying for something of this sort for thirty years, but the late Director of the Museum (Sir Sydney Cockerell, Director 1908–1937) who had a talent for begging, couldn't be got to take any interest in modern painting and the prospects were growing dimmer; we shall now have quite a respectable show, and, what is

perhaps more important, a nest-egg. The nest-egg principle is vital to museums like the Fitzw. If you have something of the sort, the private collector says, 'here is a good museum, very weak in so and so; I shall bequeath my collection to it . . .'. If you have nothing, he says, 'Those fools don't know what is worth having'.

Captain Sykes's links with Cambridge, on the other hand, were well established. A graduate in Medieval and Modern Languages, he was admitted to the Inner Temple in 1907 and called to the Bar, but never practised. He joined the army at the outbreak of World War One, served with distinction in the Intelligence Corps, and was duly awarded both the Military Cross and the OBE. Sykes began to collect actively in the 1920s, acquiring Seurat's magical *croqueton* of the rue Saint-Vincent, Montmartre (no. 59) in 1926, and Sisley's painting of the flood at Port-Marly on the Seine three years later, both from the gallery, Reid and Lefèvre, a gallery he came to relish for its 'languid calm'. When he was first introduced to Carl Winter (director, 1946–66), Sykes was careful to discourage him from holding out expectations of future gifts; despite this, he presented a number of outstanding paintings to the Museum over the following two decades. It could be that this change of heart came about as the result of his deepening relationship with the Museum, although it is equally likely that the experience of another war, during which he lost twelve of his paintings when the London warehouse in which they were stored was bombed in 1944, may have caused him to feel that a museum would be a more secure environment in which to house his collection.

Sykes offered the first of these gifts – *Rue Saint-Vincent* (no. 59) – in 1948, to commemorate the centenary of the opening of the Museum to the public. Until then, the Museum represented 'scientific' Impressionism by only two watercolours by Seurat's fellow neo-Impressionist, Paul Signac, bequeathed by Hindley Smith some years earlier (nos. 62 and 63). Duncan MacDonald of Reid and Lefèvre wrote immediately to the director, Carl Winter, to congratulate him on the acquisition, reminding him that the Louvre had only recently acquired three panels of similar dimensions for a not inconsiderable sum, 'although none of them were better in quality'. Sykes followed this gesture with the gift of Sisley's painting of the Seine in flood (no. 13), one of a group of works widely considered as being among the finest of his high Impressionist years, and with a painting from Renoir's 'sour' period, *The Return from the Fields* (no. 17). On his death in 1966, Sykes bequeathed a further six French paintings, among which were Degas's dynamic sketch of David and Goliath (no. 27), Pissarro's snow scene at Montfoucault (no. 43), one of the series paintings of poplars which Monet had exhibited at an important one-man, one-subject exhibition in 1892 (no. 11), and a double-sided watercolour by Cézanne, which he had 'fallen to' in 1949 (nos. 57, 58).

Between the 1940s and the 1960s the campaign to boost the Museum's collection of French art, which had been initiated by Louis C. G. Clarke (director, 1937–46), was vigorously pursued by Winter. Almost immediately on taking up his directorship in 1946, Winter set about acquiring for the Museum works by two key Impressionist painters who were as yet

unrepresented in its collections: Pissarro and Monet, each bought with financial support from the National Art Collections Fund. Pissarro's painting of a woman washing dishes (no. 44) – a genre of large-scale figure painting which he began to practise at the beginning of the 1880s – seems to have entered the Museum's collection without a ruffle. The acquisition of Monet's painting *Springtime* (no. 8) five years later, however, was more fiercely contested. Winter clearly considered its acquisition important enough to consult widely before committing the Museum. In February, Sykes and Gow – the two collectors of French painting on the Museum Syndicate – were dispatched to inspect the painting in London. Gow's views are unrecorded, but Sykes told Winter that he thought it, 'Just the right size for the gallery, and it should not shock anyone, even the more timid Syndics. I never like a picture all over trees with no view through for myself but for your purposes you could not do much better at the price.'

Winter went on to seek external advice from the leading British expert in the field, Douglas Cooper, who at the time was engaged in writing the catalogue of Samuel Courtauld's collection of Impressionist and post-Impressionist paintings, and in the preparation of an associated exhibition in Paris. A brilliant and highly regarded independent scholar with an infamously lacerative tongue and a well-founded reputation for belligerence, Cooper was also regularly consulted by the Tate Gallery and other museums over potential acquisitions. Winter could only have expected a reply which would – at best – be frank. However, if he had planned it as a tactical move to gain Cooper's support, he would have been sorely disappointed: Cooper opposed the acquisition in unequivocal terms, describing it as, 'charming but dull . . . You are getting what I (following viticultural terminology) would call "an Impressionist type picture" painted after the days of Impressionism'. Cooper's views were presumably in the minority, for the painting – now among the best-loved in the collection – was acquired in spite of his objections. He might, however, have felt partially vindicated: half a century later, although the Museum has subsequently acquired three exceptionally beautiful paintings by Monet of the 1880s and 1890s (nos. 9, 10, 11), it still lacks the painting from the 'great years' of Impressionism which Cooper would have had it buy.

Around the same time that the Museum embarked – more or less controversially – on these major acquisitions, it also acquired an ally who took an unusually active personal rôle in helping to expand its collection of nineteenth-century French paintings, and Impressionism in particular. The Very Revd Eric Milner White, Fellow Chaplain of King's College and Dean of York, took to buying paintings relatively late in life with the specific intention of filling gaps in the Museum's collections. To this end, he had first proposed buying a painting by Nicolas Poussin, but was quickly steered by Winter towards the nineteenth century. The pleasure which he derived from picture-hunting on a limited budget is evident from his correspondence, and his enthusiasm eventually led him beyond the London gallery circuit to seek out the potential acquisition of works in private hands on the Continent. In the space of eight years he bought for the museum paintings by Pissarro, Gauguin, Signac (nos. 45, 50 and 61) and Courbet, using modest fees he earned through his membership of literary panels to cover the costs of

reframing. Milner White clearly enjoyed the experience of collaborating with the Museum in this way, and in 1952 wrote to Carl Winter to express his gratitude: 'I have learned much, & enjoyed much, since an ignorant ambition sought to fill the gap of a Poussin. First, merely to draw a cheque for four figures! Next, what a Museum like "ours" really wants. More than either, to look for quality far more than for name or the minor types of a good master ... Such lessons, such help, add both to my delight & to *your* possession, which is exactly the best that can be!'

Impressionist paintings continued to enter the collection throughout the 1960s, thanks to the bequests of Milner White and Captain Sykes, and, in 1964, as part of the larger bequest of the francophile A. J. Hugh-Smith, director of Hambro's bank and member of the 'illustrious court' of Edith Wharton (see nos. 14, 18–20 and 42). At the end of the following decade, however, both the character and the extent of the Museum's collection of Impressionist paintings and drawings were transformed by the bequest of Andrew Gow. Gow arrived in Cambridge in 1925 to take up a fellowship and lectureship in Classics at Trinity College, and quickly established links with the Museum through its director, Louis Clarke. He served as a Museum Syndic for over thirty years, and also, between 1947 and 1953, as a Trustee of the National Gallery. Gow's dominating passion for the work of Degas seems to have been fired in around 1938: 'I am increasingly excited by him,' he wrote to Louis Clarke, 'and if I saw one which took me by storm might easily be tempted into an extravagance.' Temptation soon arrived, and the following year he bought his first drawing – a black chalk drawing of a woman washing (or drying?) her neck (no. 37) – for £45, and later the same year, with not a little financial anguish, acquired Degas's sensitive study of a dancer adjusting her tights (no. 35) for over double that sum. After the Second World War, when Gow felt able to be more extravagant in his acquisitive ambitions, he found that prices for pastels and large-scale oils were beyond his reach, but was nonetheless able to acquire two paintings, which, if modest in scale, provide fascinating insights into Degas's preoccupations in the early part of his career (nos. 21 and 22). That Gow derived enormous aesthetic pleasure from his collection is beyond doubt, but he also maintained a scholarly curiosity in his acquisitions, seeking out provenances and the opinions of both museum personnel and scholars working in the field. In the case of Degas, he entered into a regular correspondence with Paul-André Lemoisne, curator and author of the seminal four-volume catalogue of Degas's works. Their relationship was both cordial and mutually beneficial, Gow acting as an intermediary with private collectors and London dealers, Lemoisne offering opinions on Gow's recent acquisition and gaps in his collection. By the end of the 1940s, Gow had, Lemoisne conceded, put together a '*très bel ensemble*' of works by Degas, lacking only a portrait later than that of his sister, Thérèse (no. 23), which Gow, alas, was never able to acquire. Interestingly, Lemoisne was more reserved about Gow's later acquisitions – the magnificent nude with left arm raised (no. 40) and the study on tracing paper of a dancer fanning out her skirts (no. 39), both of which had been bought at the Degas sale by the art critic Félix Fénéon. Although they

added another dimension to his collection of Degas drawings, and thus made the group more representative, they were also, Lemoisne wrote, characteristic of Degas's late drawings, in exhibiting 'more strength than charm'.

Despite the extraordinary sums fetched by Impressionist paintings in the last years of the twentieth century, the Museum has continued to add to its collection. To do so, it has relied on a number of charities and trusts, as well as on the enlightened acceptance-in-lieu system, by means of which it was able to acquire in 1982 a marvellous Degas pastel of dancers (no. 38), and in 1998 two extraordinary seascapes by Monet (nos. 9 and 10). The support of the National Art Collections Fund, the Victoria and Albert Museum Purchase Fund and occasionally, too, the generous response of individuals to public appeals, have proved vital in enabling the acquisition of important paintings by Pissarro, Monet and Renoir; while a few private collectors have given works to the collections, in a spirit of altruism which is all the more remarkable in this most sought-after area of the art market (nos. 51 and 64).

Ultimately, Gow's legacy was to have perpetuated the framework for giving that he considered so key to the vitality of the Museum and its collections, and to have established a fund for the acquisition of paintings which bears his name. In 2000, thanks to it, and to the support of the National Art Collections Fund, the Museum was able to acquire a luminous early landscape by Degas (no. 24), which breathes a serenity and assuredness that disguises his intense artistic searching in this early phase of his career: while in no sense an 'extravagance', Gow would surely have approved.

I

CLIFFS NEAR DIEPPE

ADOLPHE-FÉLIX CALS
Paris 1810–1880 Honfleur

-

Oil on canvas. 20.7 × 31.7 cm.
Signed and dated, lower right: Cals 7bre 1862.
Bequeathed by John Tillotson, 1984; received 1985. PD.122–1985

Cals was a generation older than many of the Impressionist painters, but his search for a painterly independence earned him the admiration of his younger colleagues. He was notoriously protective of his artistic integrity, and refused to paint to please the public, simply in order to sell; rather, his ambition was, he claimed, 'to make real art, that is to paint what one feels, despite the risks and dangers'. He began his career as an engraver, painting in his spare time, but around 1826 entered the studio of Léon Cogniet (1794–1880). He exhibited regularly at the Salon between 1835 and 1848, and in that year he met Firmin ('Père') Martin (1817–91), a builder-turned-picture dealer who had also supported Troyon, Millet, Corot, Pissarro and Jongkind in difficult financial times. At the end of the following decade, Martin introduced him to Count Armand Doria, the first owner of this painting, who would become his most influential patron. Throughout the 1860s, Cals worked from a pavilion of Doria's château at Orrouy, near Compiègne, and during this time, too, worked alongside a group of *plein-air* painters that included Pissarro, Jongkind, Monet and Boudin, at the farm at Saint-Siméon in the hills above Honfleur. From 1871, he divided his time between Paris and Normandy, but eventually settled in Honfleur in 1873. At Monet's invitation, he sent a group of paintings to the first Impressionist exhibition in 1874, and thereafter participated on a further three occasions, in 1876, 1877, 1879, as well as posthumously, in 1881.

Cals painted the cliffs on the Normandy coast near Villerville and Dieppe in 1862, and again after his definitive return to Normandy the following decade. Although much of his work is reminiscent of the sombre naturalism of the Hague School, the high-toned palette and lively handling of this small painting show a direct response to nature that recalls the work of other precursors of Impressionism, such as Charles Daubigny, who himself painted at Villerville from the mid-1850s.

A slightly more finished version of the painting, also signed and dated 1862, is in the collection Peindre en Normandie in Caen.

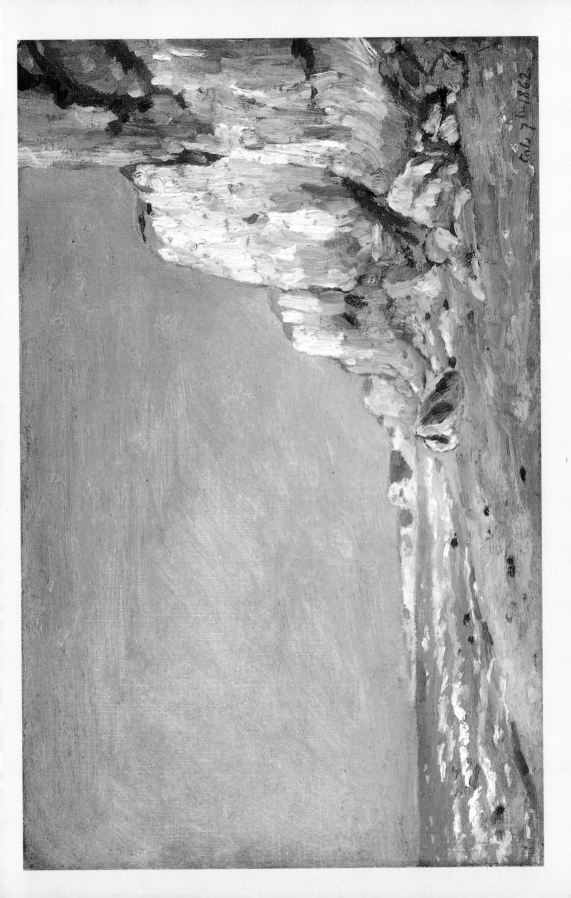

SUNSET ON THE BEACH

EUGÈNE BOUDIN
Honfleur 1824–1898 Deauville

•

Pastel on buff paper. 177 × 290 mm.
Studio stamp, lower left and lower right.
Bequeathed by Frank Hindley Smith, 1939. No. 2380

Boudin used pastel extensively in the early part of his career. Between 1854 and 1859 he regularly exhibited groups of pastels in Le Havre and elsewhere, and in 1874 sent several to the first Impressionist exhibition. From the beginning of the 1860s, however, he worked almost exclusively in oil and watercolour, and, although his pastels proved popular at the public sale of his work in 1868 – notably among painters – he does not seem to have taken up the medium again until the 1880s.

The precise date of this work is difficult to establish, although comparison with similar works in the Musée Boudin, Honfleur, and in the Louvre suggests that it was drawn at the end of the 1850s. Boudin had been interested in capturing the colouristic effects of setting sun on sea since at least 1854, when he recorded that he was trying for the twentieth time, 'to convey the delicacy and the charm of the light that plays all around [me]. As the air is cool, it is soft, faded, slightly pink. All objects are immersed in it . . . The sea was superb: the sky molten and velvety. It then turned yellow and became hot, then the sun, as it was setting, threw a beautiful purple light over the whole'. In fact, Boudin's ability to render the moods and effects of the sky was much admired by his contemporaries. Courbet, with whom he painted (and partied) in Honfleur in 1859, told him, 'You alone know the sky', while one of his own artistic heroes, Corot, whom he met in 1861, nicknamed him the 'King of the Skies'. Most rapturous of all in his praise was the poet Charles Baudelaire, who described these pastel *études* as, 'prodigious spells of air and water', which went to his head, 'like an intoxicating drink or the eloquence of opium'.

As with his paintings, Boudin came to have very clear ideas of how his pastels should be framed, believing that his skies were best enhanced by a 'Whistler-style' frame.

FISHERWOMEN IN BRITTANY

EUGÈNE BOUDIN

Honfleur 1824–1898 Deauville

-

Black chalk and watercolour on laid paper. 133 × 211 mm.
Atelier stamp, lower right.
Bequeathed by G. J. F. Knowles, 1959. PD.36–1959

'Watercolour is not very difficult,' Boudin wrote to a friend, 'it is [just] a question of proceeding with a sense of order.' Boudin took up watercolour in the 1860s, probably under the influence of his friend Jongkind, and used it both to make studies for larger oil paintings, and for independent compositions. On the whole, he favoured English papers and watercolour paints, recommending Rowney watercolour boxes, and Whatman paper of varying finishes for different scales of work, but retained a patriotic allegiance to Paillard cakes, which he considered to be more durable. Despite this, he did not work in the pure watercolour style of the British school, but instead combined watercolour washes with a linear medium – most often pencil or black chalk – to produce what he himself referred to as *dessins rehaussés* ('heightened' or 'reworked' drawings).

Boudin's attachment to Brittany was reinforced after 1863, by his marriage to Marianne Guédès, a young Bretonne who worked in Finistère; by 1867, he claimed to feel like a native, telling his friend, Martin, that, 'as we Bretonise ourselves, so we become Bretonified'. The sea, and the activities it generated – shipping and fishing – dominated his Breton subjects. However, he was also attracted to the picturesque qualities of local costume and traditions, which he studied in some depth, and to the primitive qualities that would draw Monet, Renoir and Gauguin to the region in the 1880s. He made his Salon début in 1859 with a scene representing the *Pardon at Sainte-Anne-la-Palud* (1858, Le Havre, Musée des Beaux-Arts), and continued to record the strongly religious character of the region in paintings throughout his career. The hard-working and pious Breton women feature in many of these, generally either at work or at prayer. Boudin certainly enjoyed painting the distinctive variations of regional costume, but he also had an undeniable partiality for the charms of the *Bretonnes*, whom he found 'surprisingly coquettish, dressed like queens . . . they spend their lives working in the fields, and looking after animals and have hardly any time to show themselves off'.

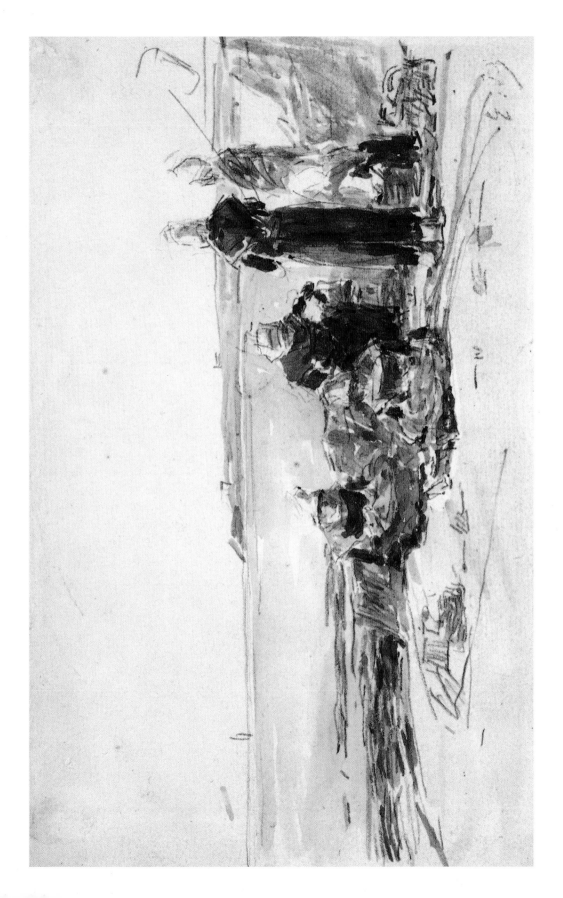

4

LOW TIDE, PORTRIEUX

EUGÈNE BOUDIN
Honfleur 1824–1898 Deauville

-

Oil on canvas. 32 × 46 cm. Signed, lower left: E. Boudin; inscribed and dated,
lower right: Portrieux / 73. Bequeathed by Sidney Ernest Prestige, 1965,
with a life interest to his widow, received, 1968. PD.12–1968

Like no. 5, this painting was executed a year before Boudin was invited to exhibit in the first exhibition of the Société Anonyme et Coopérative des Artistes Peintres, Sculpteurs et Graveurs & c., the group subsequently referred to as the Impressionists. This was the only one of the eight exhibitions in which he participated, and even then he was careful not to ally himself exclusively to the group, exhibiting two paintings – both views of Portrieux – at the official Salon the same year.

Portrieux (now Saint-Quay-Portrieux), in the bay of Saint-Brieuc, Côtes du Nord, Brittany (see no. 61), was a popular village with painters, and Boudin visited it on several of his trips to Brittany between 1865 and 1897. Like many artists, he relished the primitiveness of these Breton sites, especially by comparison with the tamer coastline of his native Normandy, with what Jules Michelet in 1861 (*La Mer*) described as its 'insipid Anglicism . . . and vulgarity'. As the son of a ship's captain who had worked as a cabin boy on ships plying the Channel coast, Boudin was perfectly placed to recognize, and record, the individual characteristics of the vessels he came across in the ports he visited; in Portrieux, he focused particularly on the fishing vessels from Newfoundland, the *Terre-Neuvas*, becalmed at low tide, and painted at least six works on this theme. In doing so, he was conscious of the precedent of seventeenth-century marine painters of the Dutch School, such as the van der Velde and Simon Vlieger, whose work he considered himself to be adapting to contemporary taste. Part of the modernization process, as he perceived it, was the more generalized treatment of form: 'They are not so perfect in details as their Dutch counterparts – nor would today's public have them so – yet I flatter myself that a future public will view them with an interest for what they show of sails, rigging, and general state of ports in our day.'

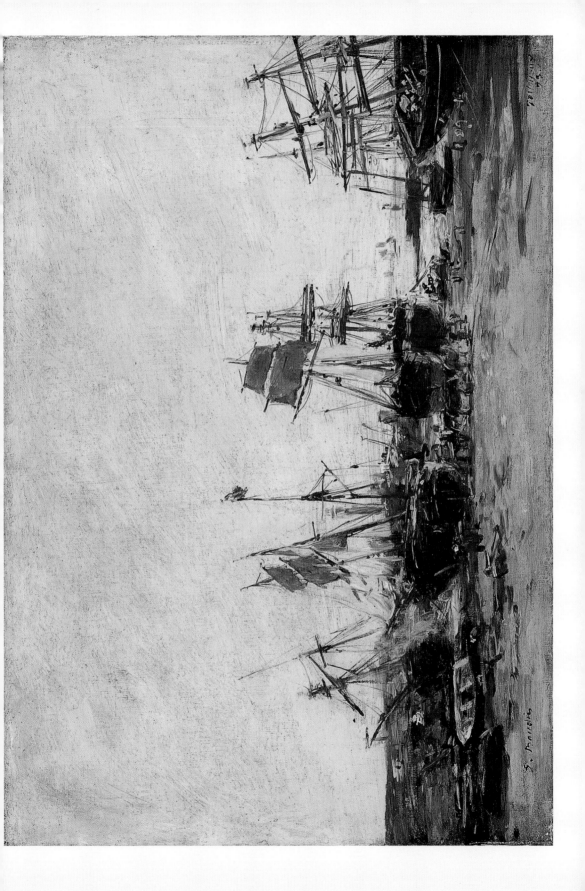

THE BEACH AT TROUVILLE

EUGÈNE BOUDIN

Honfleur 1824–1898 Deauville

●

Oil on canvas. 19.2 × 33.2 cm. Signed and dated, lower right: E. Boudin 73.
Given by the Friends of the Fitzwilliam, 1936. No. 1774

Trouville, on the Normandy coast, was one of the most fashionable resorts of the day. Much has been made in recent literature of the impact of improved access to this and other coastal towns, as a result of the installation of direct railway links with Paris from the early 1840s to 1860, when a line was opened to Trouville. In response to the increased number of visitors, a tourist infrastructure, centred on the casino, rapidly established itself, with the construction of bathhouses and the creation of elaborate facilities for renting out guides and bathing paraphernalia of all kinds.

A Norman by birth, Boudin would have witnessed at first hand the transformations that the increased levels of tourism brought to the region. He began to paint beach scenes at Trouville in 1860, probably at the suggestion of Eugène Isabey (1803–86), an acquaintance from his days as a framer and stationer in Le Havre in the early 1840s, and by the end of the decade was also producing watercolours on the same theme with considerable commercial success. That these paintings were considered as much fashion pieces as seascapes is evident from titles such as *Crinolines on the Beach*, under which they were exhibited in his own lifetime; Boudin's own reputation was as a *peintre de mœurs* – a painter of contemporary fashions and customs – who was admired for having the audacity to depict beach-goers in modern overcoats and modish female accessories.

From his correspondence, it appears that his feelings towards Trouville were ambivalent. Its affected character became increasingly jarring when compared to the wildness and simplicity of Brittany, which he visited regularly from 1855 (see no. 4); as he wrote to his friend Ferdinand Martin, the beach which he had once loved had become an appalling 'masquerade', frequented by a 'horde of good-for-nothing posers'. Despite this, and the repeated exhortations of friends to vary his subject matter, he continued to paint the throngs of *villégaturistes* throughout the remainder of his career, generally using, as here, a standard canvas format known as *marine basse*, introduced in the 1850s.

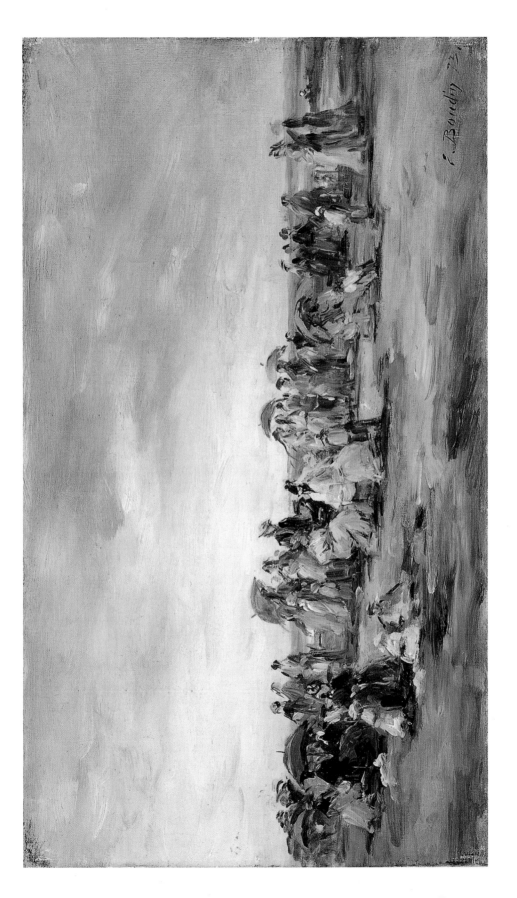

THE DOCKS AT LE HAVRE

EUGÈNE BOUDIN

Honfleur 1824–1898 Deauville

—

Oil on panel. 31.8 × 40.8 cm. Signed and dated, lower right:
E. Boudin / 87; and, below: 20 Octobre; to the left (partially erased):
20 Octobre. Given by E. Vincent Harris, OBE, RA, in memory
of his wife Edith, 1967. PD.7–1967

Boudin was born in Honfleur, but moved with his family to Le Havre, a few miles along the Channel coast, in 1835. The town had suffered considerably under Napoleon, but its fortunes were restored with the Peace of 1815, and from 1853 the personal intervention of Louis-Philippe ensured the rapid expansion of its marine installations. Later in life, Boudin claimed to have a special attachment to Le Havre, as the town that had launched him on his artistic career, by providing him with an annual grant of 1,200 francs to study in Paris between 1851 and 1854.

Like Trouville, Le Havre featured frequently in his paintings from the 1860s, no doubt partially in response to the extraordinary pace of the development of the town. His views of the port contrast sharply with those of the coastal resort, however, being almost devoid of human presence. Instead they focus on its commercial nature – at any one time at least 1,500 ships could be received between the outer harbour and the seven docks – and the constant activity of passenger and merchant shipping; it is hardly surprising, therefore, that the town came to be known as the *Liverpool français*, and to be described by Stendhal in 1838 as 'the most exact copy of England' in France. Precisely which of the docks is represented in this painting remains uncertain, although it may be the Vauban dock or the Old Dock, which was reserved for steamers of the imperial fleet and merchant shipping. In general, Boudin had a marked preference for depicting the 'elegant allure' of sailing craft and regretted their disappearance with the advent of shapeless iron 'boilers'. The rapidly applied brushwork, and the fact that it is twice dated 20 October [18]87, suggests that this painting was executed during a single painting session. The summary verve with which it has been painted confirms Boudin's belief that paintings made on the spot, 'always have a force, a strength and a lively touch that can never be recaptured in the studio'.

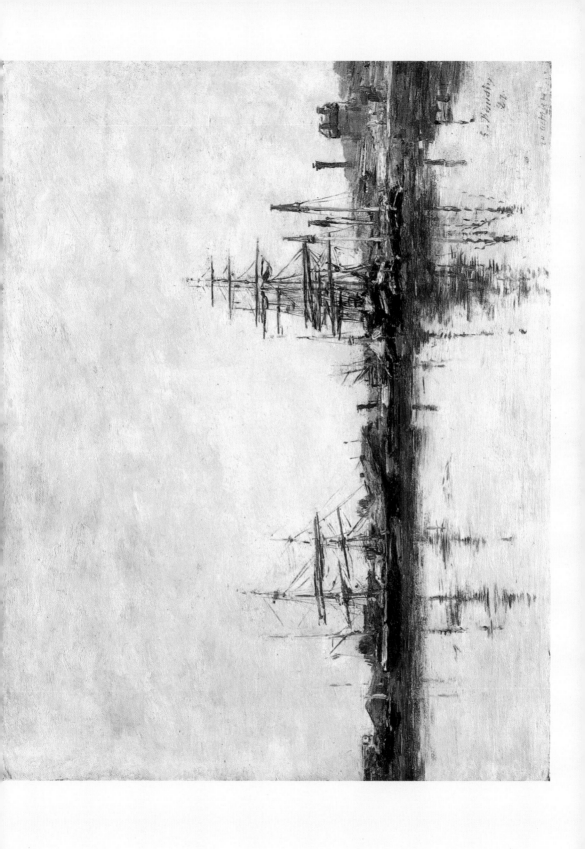

THE JETTY AND LIGHTHOUSE AT HONFLEUR

EUGÈNE BOUDIN
Honfleur 1824–1898 Deauville

●

Oil on panel. 18.7 × 24 cm. Given by E. Vincent Harris, OBE, RA,
in memory of his wife Edith, 1967. PD.6–1967

Boudin left Honfleur fairly early in his career, in 1861, partly incited by friends such as the sculptor Jules Bonnaffé, who urged him to come to Paris and to leave 'that infernal hole of a town, inhabited only by idiots'. He nevertheless continued to paint there throughout his life, so that his views of the town can often be difficult to date.

Although an inscription on the back of the wooden panel identifies the scene as the jetty and outer harbour of Le Havre, the prominence of the lighthouse at the end of the pier is more characteristic of Honfleur. The handling of the paint, applied fluidly, with a broad, choppy brush stroke, suggests that it was painted at a relatively late date, probably in the late 1880s. This date is supported by the fact that the painting once belonged to Eugène Adam, an avid collector of Boudin's paintings between 1884 and 1891, who generally bought directly from the artist.

One of the clearest differences between Boudin and other Impressionist painters lay in his attitude to finish. Despite his preference of a high-toned palette, he maintained the belief that the paint surface should be carefully modelled, without overemphasizing the brushwork; even in small paintings, he wrote, one should 'leave no traces of the brush'.

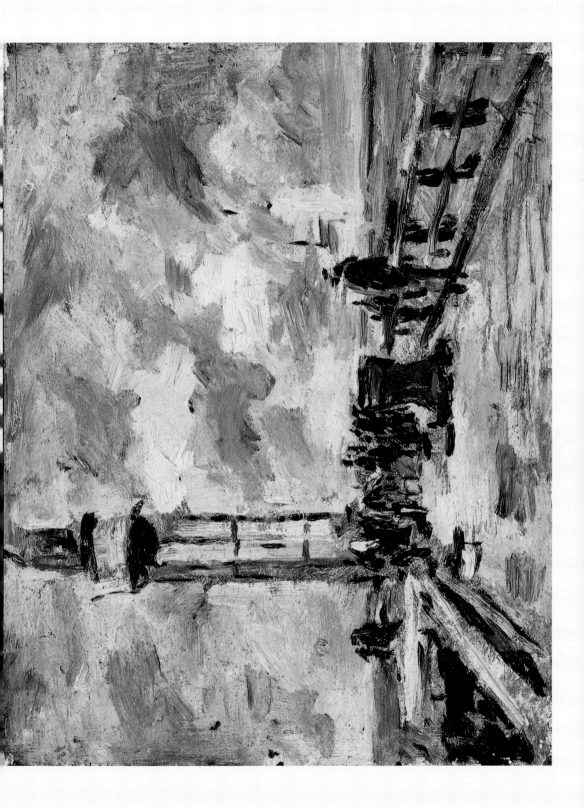

8

SPRINGTIME

CLAUDE MONET
Paris 1840–1926 Giverny

—

Oil on canvas. 64.8 × 80.6 cm. Signed and dated, lower left:
Claude Monet 86. Bought, with the aid of the
National Art Collections Fund, 1953. PD.2–1953

This was the first painting by Monet to enter the Museum's collections, in 1953 (see p. 8). Painted in the orchard of Monet's garden at Giverny in 1886, the figures have been identified as Suzanne Hoschedé, the 18-year-old daughter of Monet's then mistress – and eventually second wife – Alice, and his own son, Jean Monet, who later married another of the Hoschedé daughters, Blanche.

Monet first visited the house – known as 'Le Pressoir' – as a prospective buyer in May 1883, and, according to Mme Salerou (née Hoschedé), was immediately attracted to the flowering fruit trees in the garden, which surrounded the house. He moved there at the end of the same year, after a short interlude at Poissy Proerty.

The tonality of this painting perfectly exemplifies the 'violettomania' or 'seeing blue' for which the Impressionists were repeatedly criticized: one commentator in 1877 described the general effect of the third Impressionist exhibition as having the bluey-green tonalities of worm-eaten Roquefort cheese! Such adverse critical reaction arose principally in response to the practice of rendering light effects using a uniformly high-key palette and shadows as a violet hue, rather than toning down their pigments by adding black. Here the dense network of trees and crocheted canopy of white blossom deny any traditional sense of spatial recession, drawing attention to the rhythmic texture of the brushwork and pattern of the interwoven strokes of pinks, reds and blues.

The painting was bought from the artist in January 1887 by Jean-Baptiste Faure (1830–1914), who was one of Monet's most important patrons from the mid-1870s. An enormously successful baritone, whom Verdi considered to be the only singer of note at the Opéra, Faure had acquired some six months earlier five of the twelve paintings which Monet had shown at the fifth Impressionist exhibition held at Georges Petit's gallery. In all, Faure bought sixty-four of Monet's paintings, but his buying was largely speculative, and he sold them all on at a profit.

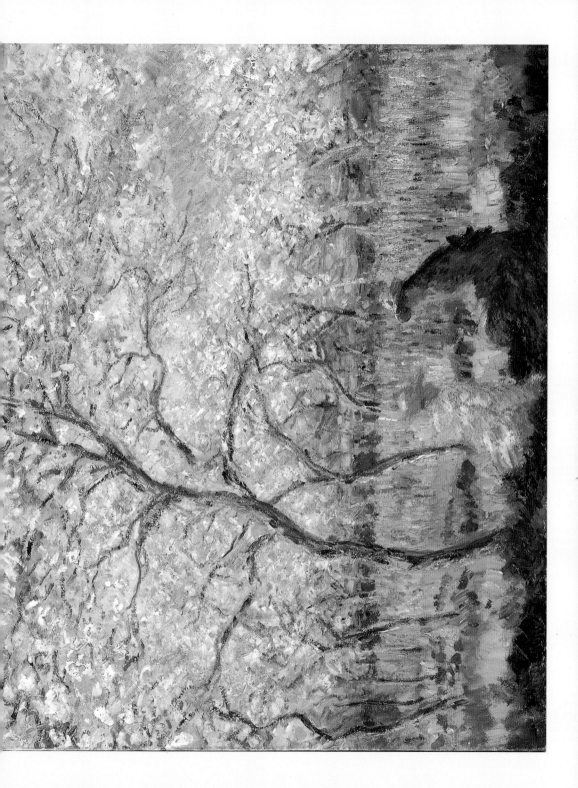

THE ROCK NEEDLE AND PORTE D'AVAL, ÉTRETAT

CLAUDE MONET
Paris 1840–1926 Giverny

⬤

Oil on canvas. 64.8 × 81 cm. Monet's studio stamp, lower right.
Accepted in lieu of Inheritance Tax by HM Government and allocated to the
Fitzwilliam Museum, 1998. PD.26–1998

Like a number of artists before him, notably Delacroix, Boudin and Courbet, Monet was captivated by the spectacular rock formations at Étretat. He made his first prolonged visit to this part of the Channel coast in 1868 with his wife Camille and their son, and returned again in 1883. This painting was executed during a visit in the autumn and winter of 1885/86, in the course of which he painted over half the known views of this location.

During the first decades of the nineteenth century, Étretat, near Le Havre on the Normandy coast, transformed itself from a small fishing village to a popular seaside resort. None of Monet's paintings shows any evidence of the town's bustling tourist activity; few, indeed, betray human presence of any kind. Instead, his vision is directed seawards, to the ever-changing colours of the water and the outstanding natural beauty of the coastline. This view was painted from the cliff not far from the top of the Manneporte to the west of Étretat. It may be the sketch for a signed painting of the same subject, dated 1885 (Wildenstein 1996, III: no. 1032), which also depicts the sailing boats – here included as a decorative, almost ghostly presence somewhat reminiscent of Whistler's butterfly signature.

The novelist Guy de Maupassant, who visited Monet during his stay, described the resoluteness with which he pursued his subject: 'No longer a painter, he had become, truly, a hunter. He walked along, followed by the children who carried his paintings, five to six canvases showing the same subject at different times of day with different effects. He took them up or abandoned them as the changing sky dictated.'

Monet's astonishing ability to paint the effects of movement, stillness and light on water was praised by many of his contemporaries, among whom Émile Zola, Stéphane Mallarmé and Octave Mirabeau. Comparison with his painting of the Breton coast at Belle-Île, painted the following year (no. 10), confirms his versatility, as he relishes the sea's swings of mood, from the tempestuous, wave-torn surface of the latter to the blissfully limpid depths of the present painting.

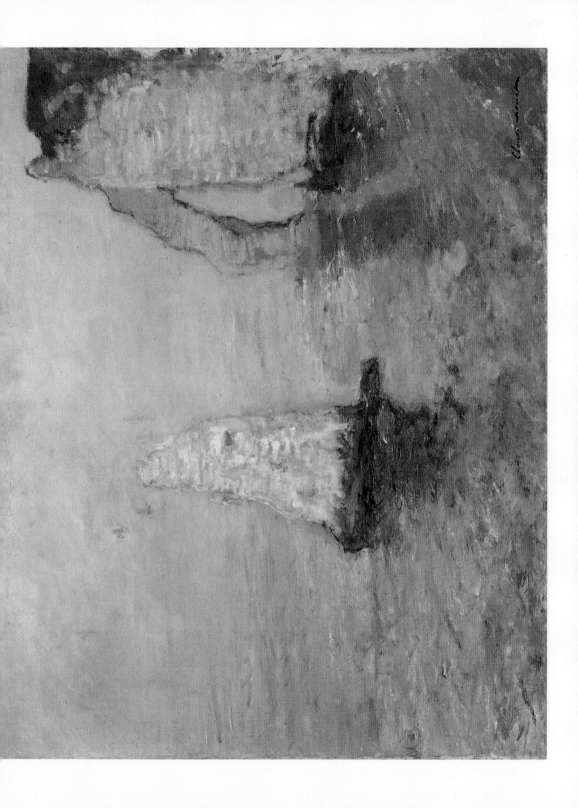

ROCKS AT PORT-COTON, THE LION ROCK, BELLE-ÎLE

CLAUDE MONET

Paris 1840–1926 Giverny

—

Oil on canvas. 65 × 81 cm. Signed and dated, lower right: Claude Monet 1886.
Accepted in lieu of Inheritance Tax by HM Government and allocated to the
Fitzwilliam Museum, 1998. PD.27–1998

Monet visited the west coast of Brittany for the first time in the autumn of 1886. He would have known of its attractions through his friend, Eugène Boudin, who painted there on many occasions from the mid-1850s; however nothing prepared him for his first encounter with the so-called 'wild coast'. Although he had planned to stay only ten days, he ended up spending ten weeks there, based in the hamlet of Kervilahouen, only 500 metres from the rugged coastline. This is one of thirty-nine paintings executed during his stay.

The effects of sea and sky on the Atlantic coast were quite different to those he had experienced in Normandy, and to begin with he found the prolonged bad weather and unpredictability of the tides frustrating. To cope with the appalling conditions, he had his paints covered by a wax sheet and his easel tethered to the cliff top using ropes and stones. Despite these difficulties, Monet welcomed the challenge of this new environment, recognizing that his efforts to capture the 'sinister, tragic' quality of the Breton landscape had led him to abandon his habitual 'soft, tender tones' in favour of a palette better suited to the formidable surroundings. Here, for example, he uses colours that are darker in tone, but still varied in hue. The rocks – which to him appeared black, and blacker still when wet – are rendered in a range of browns, bottle greens, russets and mauves to give the patinated appearance that the writer Gustave Geoffroy, who visited Monet in October 1886, described as one of the most characteristic features of the coast. Monet was also quick to perceive the commercial advantage of his new subject matter, which prevented him from being typecast as a painter of sunny Mediterranean climes; as he explained to his dealer, Durand-Ruel, 'one must not specialise in one chord alone'.

Compositionally, this painting shows the influence of Japanese ukiyo-e woodblock prints on Monet's work, in particular those by Hokusai. It was acquired by Théo van Gogh in April 1887, and sold on a year later at double the price.

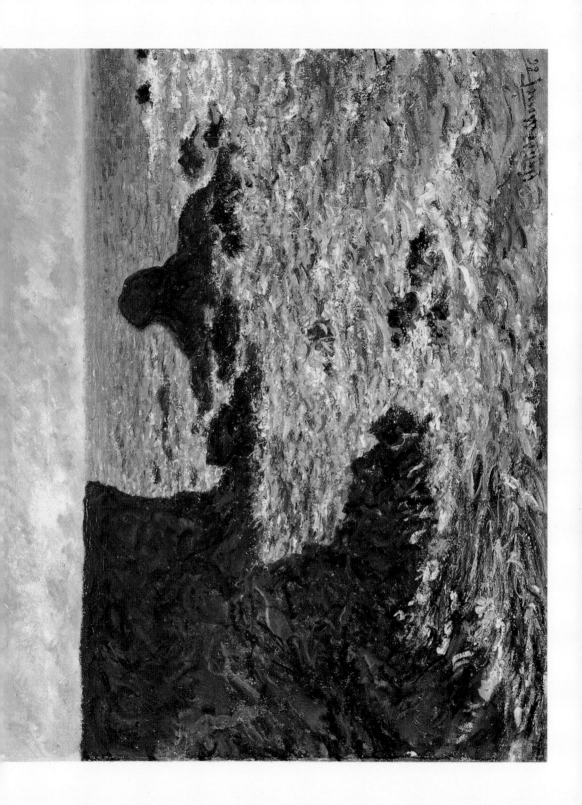

II

POPLARS

CLAUDE MONET

Paris 1840–1926 Giverny

⬤

Oil on canvas. 89 × 92 cm. Signed, lower right: Claude Monet.
Bequeathed by Captain Stanley William Sykes, OBE, MC, 1966. PD.9–1966

In the summer of 1891, Monet painted a series of canvases of the poplar trees on the south bank of the Epte, at the edge of the Limetz marsh, two kilometres upstream of his home at Giverny. Working from a sturdy boat-studio large enough to sleep in, he represented the poplars under a variety of weather conditions, in spring, summer and autumn, concentrating on the sinuous curves formed by the line of trees. Monet had barely begun to work on the series when he almost lost his motif. In June the poplars were put up for sale by the village, and, although his plea for a stay of execution was turned down by the mayor, Monet came to a financial arrangement with the timber merchant who had bought them at auction, which left the trees standing long enough for him to finish painting them. This is one of only two in the series to be seen from the marsh.

Monet began to exhibit his paintings in series at the beginning of the 1890s, and the following year exhibited a group of fifteen paintings of haystacks as part of a mixed exhibition at the Durand-Ruel Gallery in Paris. The critical praise they received encouraged him to proceed with a second series, which he painted over the remaining months of the year. By the beginning of 1892 he had completed twenty-three canvases, fifteen of which were exhibited as a discrete series at Durand-Ruel's at the beginning of March. The impact of the series was immediate. While Sisley (no. 13) and Monet had both painted series of compositions on a single theme in the mid-1870s, this was the first time a landscape painter had so rigorously explored a single motif through a series of different canvases. Monet's effort to record the changing appearance of the trees in different seasons and lights as well as the 'atmospheric envelope' that surrounded them created an overall effect, which, as critics observed, was anything but naturalistic, and Monet further enhanced the decorative effect by painting the entire series on unusual square-shaped canvases.

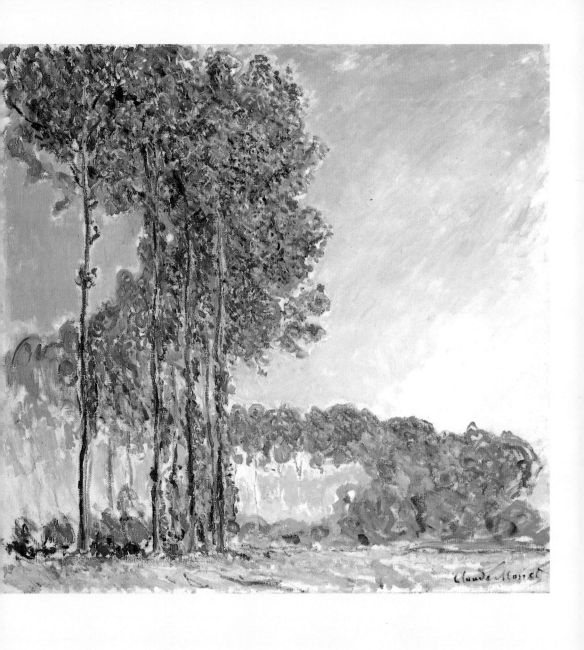

A STREET, POSSIBLY IN PORT-MARLY

ALFRED SISLEY

Paris 1839–1899 Moret-sur-Loing

•

Oil on canvas. 46.4 × 36.7 cm. Signed, lower right: Sisley.
Bequeathed by Frank Hindley Smith, 1939. No. 2414

Although the Impressionists were generally associated with landscape painting, Sisley was the only one of the group who sent exclusively landscapes to their exhibitions. He exhibited at four of the eight group shows, in 1874, 1876, 1877 and 1882, but, with Renoir, and later Monet, chose to send his paintings to the Salon again in 1879 (although his submissions were, in the event, rejected). Thereafter – stimulated as much by financial difficulties as by personal choice – he chose to market his work independently, if not always successfully, through a series of joint and one-man exhibitions at dealers' premises.

The date and location of this painting have been much disputed. Since it was first published in 1959, it has been severally identified as Moret-sur-Loing, Louveciennes, Port-Marly and Ville d'Avray, and dated both around 1876 and 1892. Like Corot, Chintreuil and Daubigny before him, Sisley lived for long periods in villages along the Seine to the west of Paris, but in 1880 moved to Veneux-Nadon to the south-east of Paris, eventually settling in Moret-sur-Loing in 1889. From 1871 to 1875 he lived in Voisins-Louveciennes, and during the subsequent five years lived at Marly-le-Roi and Sèvres, and from these bases made regular painting expeditions in the surrounding countryside and villages in search of pictorial motifs, so that identification of a particular site is not necessarily a clue to its dating. The subject – a village street set on a gently descending slope – the play of shadows cast by the buildings which line it, and the vigorous, rhythmic painting of the sky all suggest a date of around 1875–77, while Sisley was resident in Louveciennes. While the precise location of the view remains to be established, the season – so the high cloud, 'hot' blue sky and strength of the shadows tell us – is clearly summer. Sisley believed that different effects of light should be rendered in a painting by a variety of paint surfaces and textures as, 'when the sun lets certain parts of the landscape appear soft, it lifts others in to sharp relief'.

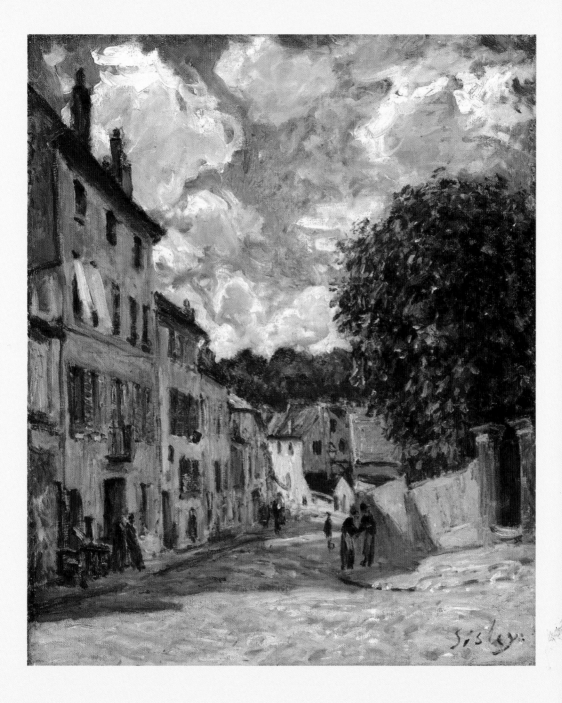

THE FLOOD AT PORT-MARLY

ALFRED SISLEY

Paris 1839–1899 Moret-sur-Loing

•

Oil on canvas. 46.1 × 55.9 cm. Signed and dated, lower right: Sisley 76.
Given by Captain Stanley William Sykes, OBE, MC, 1958. PD.69–1958

Port-Marly lies on the left bank of the Seine, between Saint Germain-en-Laye and Bougival. Sisley painted there from 1871, when he moved to nearby Voisins-Louveciennes, and sent two views of the town to the first Impressionist exhibition in 1874.

He first recorded the Seine in flood there in 1872, and returned to the subject after the extensive flooding in the spring of 1876. This is one of seven views of the town under water that he painted in that year – one of which he exhibited at the second Impressionist exhibition in April 1876. The other five views all depict views of the town looking downstream towards the avenue Jean Jaurès; this is the only one of the group to show the flooding from the opposite direction.

Sisley's concentration on a single subject – while not so systematically pursued as Monet's series paintings of the 1890s (see no. 11) – nevertheless helps to illuminate his principal painterly objective: to render the extraordinary quality of the watery reflections under changeable springtime weather. Here, he shows the flood gradually receding, the muddy tones of the water and blue-grey of the clearing sky establishing the dominant tones of the painting. The deep spatial recession created by the avenue of trees on the right, and echoed, in a minor key, by the river on the left, is offset by a number of prominent horizontal emphases, such as the punts in the foreground, the incursion of the flood water and the gable ends of the two pavilions, in accents of terracotta and blue.

For contemporaries such as Armand Silvestre and Théodore Duret, Sisley was without question the most lyrical and temperate of the Impressionist painters; the latter described his work as appealing especially to 'men of delicate sensibilities'. The particular qualities of this painting – its stillness and saturated silences – are perhaps best captured by Joris Karl Huysmans, who in 1883 described Sisley as having an 'eye less delirious' than Pissarro and Monet; as a consequence, his paintings conveyed 'a lovely melancholic smile, and . . . serene charm'.

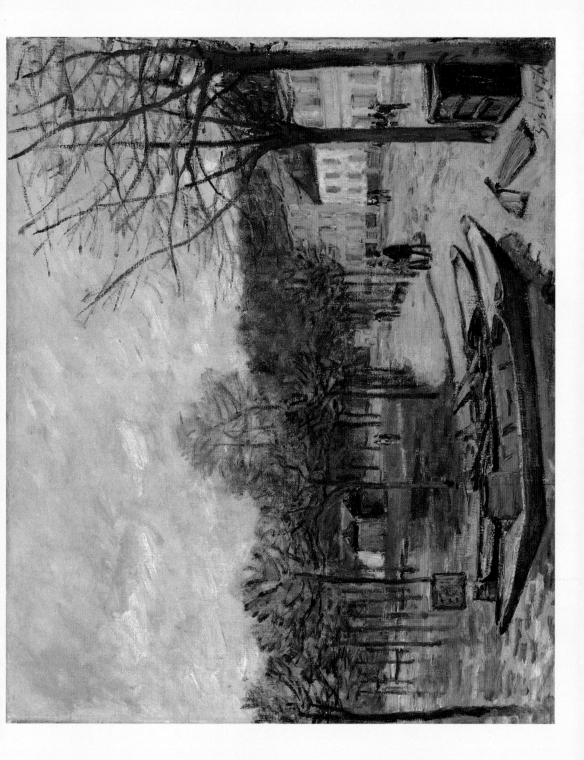

APPLES AND WALNUTS

PIERRE-AUGUSTE RENOIR
Limoges 1841–1919 Cagnes

•

Oil on panel. 13.3 × 20.3 cm. Bequeathed by Arnold John Hugh Smith through the National Art Collections Fund, 1964. PD.18–1964

Renoir claimed to paint still lifes to 'relax his brain'. Whereas before a living model he felt constrained to obey contour and form, with inanimate objects he was freer to respond intuitively in his use of colour and application of pigment: 'I can paint flowers', he wrote, 'and I need only call them "flowers"; they do not need to tell a story.' Nothing could better demonstrate his relaxed approach than comparison with Cézanne's considered analysis of form in his still life painted around 1877–78 (no. 55) – little wonder that he considered the contemplative Chardin an '*emmerdeur*' (politely: 'a bore')!

These small sketches are difficult to date with precision. The vast majority of his still lifes were painted in the last decades of his career, from the 1890s; however, the creamy impasto, clear, luminous tonality and blocky painting of the blue shadow suggests that this painting may date from relatively early in his career, in the late 1860s or early 1870s. Renoir painted a number of ambitious floral compositions at the beginning of his career, some of which, such as his *Mixed Flowers in a Vase* (1869, Museum of Fine Arts, Boston) include apples and other fruit which are painted with similar robustness and precise definition of form. It is also possible that this painting, like the *Still Life with Peaches* (exhibited Galerie Huguette Berès, Paris, 1988) was painted during 1871, when Renoir returned to Paris after the end of the Franco-Prussian war.

This sketch is said once to have belonged to the writer Edith Wharton, who was a close friend of the donor, A. J. Hugh-Smith, to whom she dedicated her book *Hudson River Bracketed*.

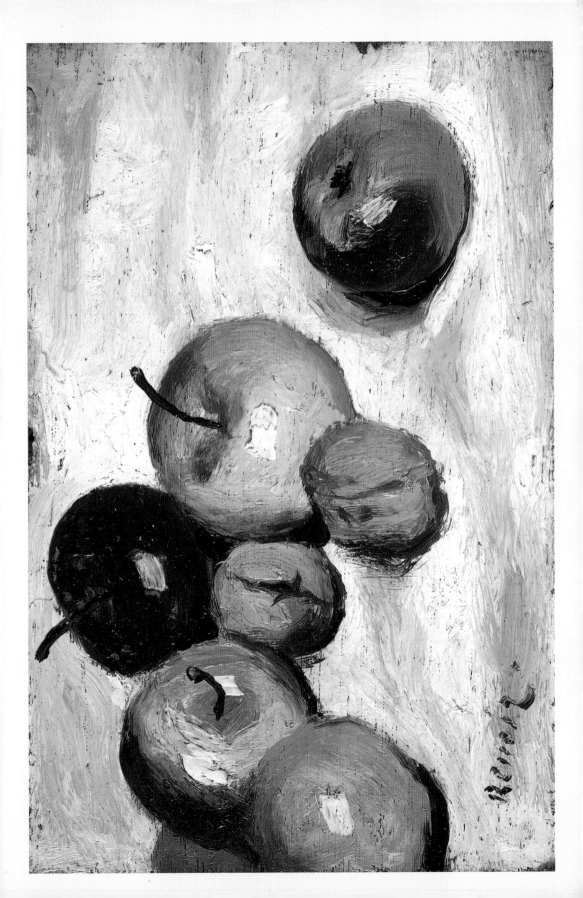

THE GUST OF WIND

PIERRE-AUGUSTE RENOIR

Limoges 1841–1919 Cagnes

•

Oil on canvas. 52 × 82 cm. Signed, lower right: A. Renoir.
Bequeathed by Frank Hindley Smith, 1939. No. 2403

Towards the end of his life, Renoir claimed to prefer a painting that made him 'want to stroll in it, if it is a landscape, or to stroke a breast or back, if it is a figure'. Few of his paintings so perfectly evoke in visual terms the sensual pleasures of the outdoors. To recreate the vivid impression of a warm, summer breeze, Renoir has brought into play a range of subtle technical devices, such as blurring the edges of form and alternating the thickness of his paint and brush strokes, so as to allow the beige ground to show through and add warmth to a predominantly cool palette of greens and blues.

This painting was probably executed around 1872. The scene is thought to be near Saint-Cloud, or perhaps elsewhere in the Île-de-France; however, as its title suggests, Renoir's aim was less to record a recognizable tract of countryside than to register that most unpaintable of elements: air. It seems likely to have been the painting entitled *Grand Vent* that Renoir sent to a selling exhibition of works organized, at his instigation, at the Hôtel Drouot on 24 March 1875, which also included works by Monet, Sisley and Berthe Morisot. The exhibition was intended to give this controversial group of painters an opportunity to display their works publicly outside the official Salon, but instead, it generated a level of hostility that nearly erupted into a full-scale riot. Financially, too, the sale was an unmitigated disaster; Renoir exhibited twenty works, for which he received an average of 120 francs – the lowest sum of any of the exhibitors. This is one of two paintings bought for 55 francs by the Swiss painter, Auguste de Molins (1821–90), who himself showed at the first Impressionist exhibition of 1874.

Landscape played an important part in Renoir's earliest paintings, but during the 1860s his work became increasingly dominated by the human figure. He later told the dealer René Gimpel that it was 'the painter's stumbling block', but that he nevertheless continued to be stimulated by the 'hand to hand struggle' with nature.

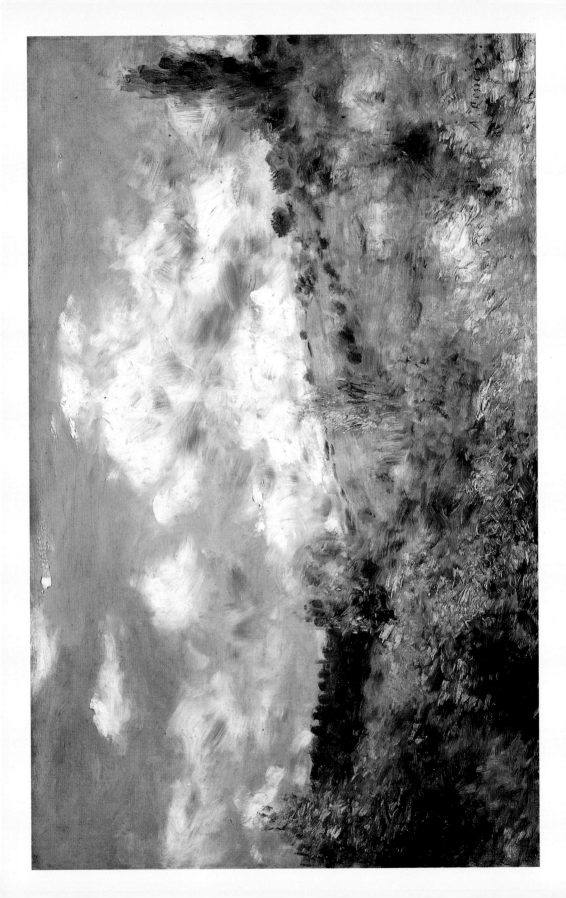

LA PLACE CLICHY

PIERRE-AUGUSTE RENOIR

Limoges 1841–1919 Cagnes

‒

*Oil on canvas. 65 × 54 cm. Signed, lower left: A. Renoir. Bought as a result
of a public appeal with contributions from the National Heritage Memorial Fund,
the National Art Collections Fund, the Wolfson Foundation through the National
Art Collections Fund, the Regional Fund administered by the Victoria and Albert
Museum on behalf of the Museums and Galleries Commission. PD.44–1986*

Renoir was the leading Impressionist painter of the Parisienne. From early in his career he was attracted both to crowd scenes and to the female form, which he has here combined in one of his most sophisticated developments of Impressionism. Although Renoir made a speciality of painting the inhabitants of Paris at leisure, in dances in Montmartre, at café concerts, or in outings along the Seine, he represented the city itself relatively rarely, and more rarely still the bustle of life in the seamier areas of Haussmann's *grands boulevards*. This scene has been identified as place Clichy since it appeared in the sale of the art critic Adolphe Tavernier in 1900, and was probably painted in Renoir's studio in nearby rue Saint-Georges in 1880.

The contrast between the more sharply focused figure in the foreground and the blurred crowd scene behind is a device that he had used in an earlier painting, located in an interior, *The Café-Concert* (1876–77, National Gallery, London), and creates the same 'bluish fog' that critics perceived in his painting, *La Promenade* (Frick Collection, New York), when it was shown at the Impressionist exhibition of 1876. The bold cropping of the principal figure and the steep recession of the street suggest the influence of Japanese ukiyo-e prints, although these were themselves influenced by western traditions of perspectival representation.

Place Clichy passed from the Tavernier collection to the Marquise Arconati-Visconti and, from 1907 to 1909, belonged to Louis-Marie-Philippe-Alexandre Bernier, Prince de Wagram (1883–1918), whom Proust described in *Le Côté de Guermantes* as, 'the young prince who liked Impressionist painting and motoring'. Two years earlier, on graduating from the military academy of Saint-Cyr, the prince began to acquire an important collection of paintings, textiles and decorative arts, which he continued to build up over a period of three years, but was forced to dispose of it almost as quickly as the result of unwise financial investments. In 1924 the painting was acquired by Samuel Courtauld, one of the earliest and most influential collectors of Impressionist painting in England, and was sold to the Museum by his granddaughter in 1986 (see introduction, p. 6).

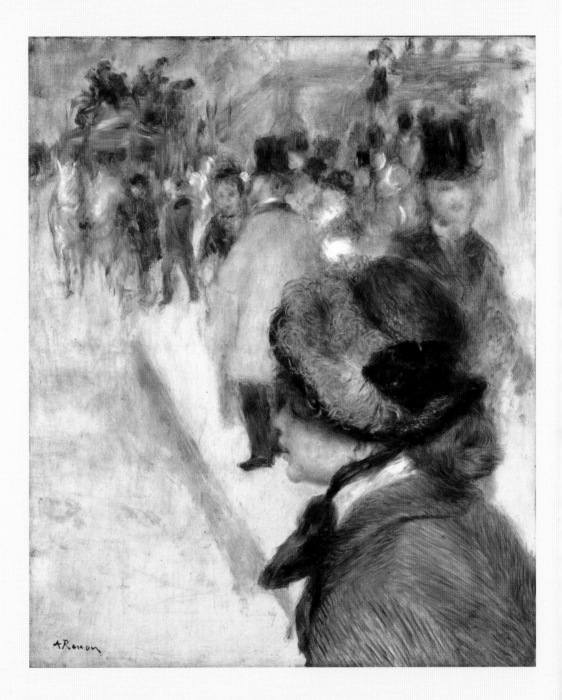

THE RETURN FROM THE FIELDS

PIERRE-AUGUSTE RENOIR
Limoges 1841–1919 Cagnes

●

Oil on canvas. 54 × 65.1 cm. Signed, lower right: Renoir.
Given by Captain S. W. Sykes, OBE, MC, 1964. PD.29–1964

Renoir travelled a great deal in the 1880s, visiting the Channel Islands, Normandy, Algeria, Italy and the Mediterranean coast. In the late summer of 1886, at the suggestion of his dealer, Durand-Ruel, he spent almost two months with his family near the so-called 'Emerald coast' of Brittany in the hamlet of La Chapelle-Saint-Briac, not far from Dinard.

Since the mid-nineteenth century, Brittany had come to be regarded as one of the few regions of rural France to have escaped the effects of modernization, and it became a popular subject in paintings exhibited at the Paris Salon. Boudin had been attracted to its comparative wildness from the 1850s (see no. 4), and Monet paid his first visit to the remote southern coast of Belle-Île in the autumn of 1886 (no. 10); a few years later its primitiveness and mystical spirit would also draw Gauguin and other artists in circle to Pont-Aven on the southern coast.

Stylistically, the emphatically linear qualities of this painting are characteristic of Renoir's work of the 1880s, which he himself defined as his '*manière aigre*' ('sour style'). This radical shift in his technique was provoked by his belief that he had reached a crisis in his own development of Impressionism, and also by the impact of his first-hand experience of the works of Raphael and other Renaissance masters during his visit to Italy in 1881, both of which led him to seek a greater definition of form in his work. To achieve it here, Renoir has used a canvas commercially prepared with white priming, over which he applied another thick layer of opaque white; this ground gives a luminosity to the colour, greater precision to the brushwork, and even allows the pencil underdrawing to show through some of the thinner paint layers.

The painting was first exhibited at the Durand-Ruel Gallery in 1892, where it was bought by the writer and painter Jacques-Émile Blanche (1861–1942), who had admired Renoir from his youth and who had taken painting lessons from him in the 1880s.

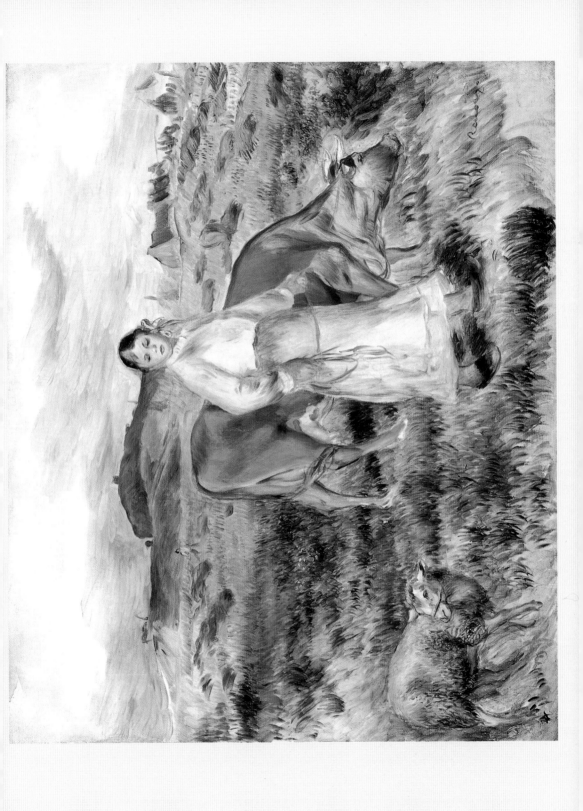

THE PICNIC

PIERRE-AUGUSTE RENOIR
Limoges 1841–1919 Cagnes

—

Red and black chalk on paper. 423 × 315 mm. Signed in graphite, lower right: Renoir.
Bequeathed by Arnold John Hugh Smith through the National
Art Collections Fund, 1964. PD.21–1964

At the beginning of the 1880s, Renoir began to paint an increasing number of scenes from rural life, a change in subject matter that has been related to his affair with Aline Charigot, a young seamstress from Champagne, whom he eventually married in 1890. Thematically, this drawing is close to paintings such as *Grape-Pickers at Rest* (Barnes Foundation, Merion, PA) and *Grape-Pickers at Lunch* (Armand Hammer Museum of Art and Cultural Center, Los Angeles), both of which are thought to date from around 1888. The relatively controlled handling of the red chalk, applied in a series of long, hatched strokes, also accords with this dating, and places it towards the end of Renoir's 'dry' or 'sour' period (see no. 17). A more finished version of this subject is reproduced in Ambroise Vollard, *La Vie et l'œuvre de Pierre-Auguste Renoir* (1919); its present whereabouts are unknown, but it was last recorded in the collection of H. Kasper, New York, in 1978.

Renoir made relatively few drawings in his high Impressionist years, but began to draw more often around 1879, partially in connection with the foundation of the journal *La Vie Moderne*, for which he made several illustrations. Red chalk was his favourite medium, and he used it a great deal in preparatory drawings for his paintings from the 1880s. While studies for works such as *Large Bathers* of 1886 (Philadelphia Museum of Art) are executed in a linear style close to this drawing, later drawings are more softly modelled, with a stumping of the red chalk to create a sense of *sfumato*, creating the graphic equivalent of what Degas described as 'painting with balls of wool'. Indeed, Renoir's painter friends appear to have held mixed views about his abilities as a draughtsman. While Berthe Morisot lavished praise on a red chalk drawing she saw in Renoir's studio at the beginning of 1886, Pissarro considered that he had 'no talent for drawing', while Gauguin – more guarded in his praise (or generous in his criticism) – called him, 'a man who does not know how to draw, but draws well'.

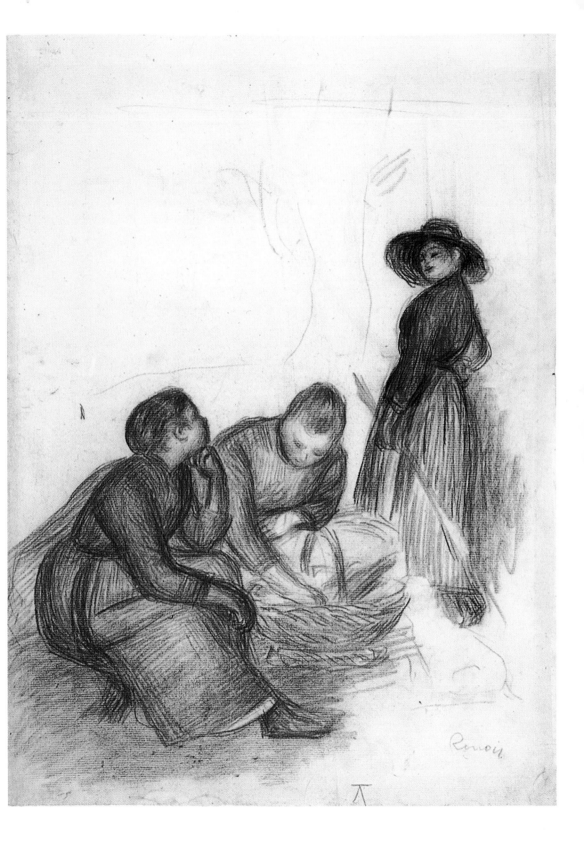

Renoir

MUSIC

PIERRE-AUGUSTE RENOIR
Limoges 1841–1919 Cagnes

—

Oil on canvas. 40 × 16.5 cm. Signed, lower right: Renoir.
Bequeathed by Arnold John Hugh-Smith through the
National Art Collections Fund, 1964. PD.19–1964

Had Renoir followed the advice of Charles Gounod (1818–93), for many years organist at the church of Saint-Eustache, he might have made a career as a singer, rather than as a painter; instead his parents apprenticed him to a porcelain painter at the age of 16, and for four years he painted blinds, café walls, and imitation Sèvres and Limoges porcelain. Although he did not frequent the Opéra with the same regularity as Degas, he was nevertheless extremely fond of music, and had a particular admiration for Berlioz and Wagner, whose portrait he first painted in 1882.

This sketch, a pair to *Dance* (no. 20), was probably painted in 1895, and, like it, is preparatory to a larger canvas of the same title, whose present whereabouts is unknown, but which was last exhibited in London in 1956. Over twenty years later, just before his death, Renoir treated the same paired subjects as bronze reliefs, which were executed in 1918 by the young sculptor Louis Morel on the basis of his drawings, as Renoir himself was unable to work in three dimensions, having suffered from debilitating rheumatoid arthritis from his forties. In fact, he made only two sculptures unassisted: a medallion and a bust of his son, Coco, made in wax in 1908 and later cast in bronze. He had also planned a further relief depicting a dancing figure wearing a wreath, but became too ill to continue working on it.

By the 1890s, Renoir had relaxed the self-conscious tightening of form that he had adopted a decade earlier (see no. 17) and returned to a greater fluidity in his brushwork and modelling of form. In contrast to Degas, who claimed to have regarded women as 'animals', Renoir preferred to think of them, and to paint them, as he would delicious 'fruits', and throughout his career clearly relished painting the soft fleshiness of his female models. In this respect, his – sometimes overripe – late nudes reveal his debt to Rubens, whose works in the Louvre he had copied so assiduously at the beginning of his career as a painter as to earn the nickname 'little Rubens'.

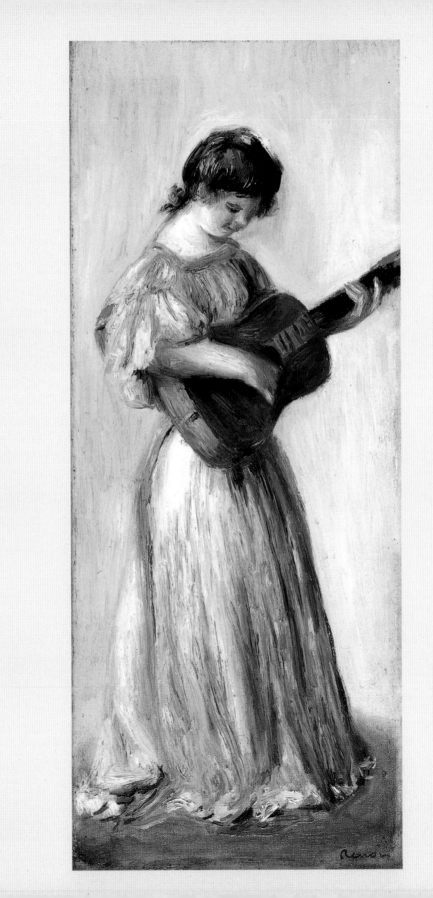

DANCE

—

*Oil on canvas. 40 × 16.5 cm. Bequeathed by Arnold John Hugh-Smith through
the National Art Collections Fund, 1964. PD.20–1964*

A pair to *Music*, painted in 1895.

The theme of dance preoccupied Renoir throughout his career. One of his first – and best-received – exhibits at the Impressionist exhibition of 1874 was a painting of a young ballet dancer (1874, National Gallery of Art, Washington), and between then and the early 1880s he frequently represented his contemporaries at balls and outdoor dances, either *en masse* – most memorably in his painting of the *Moulin de la Galette* (1876, Musée d'Orsay) – or *à deux*, as he did in a series of paintings depicting his then, and would-be, mistresses with three of his friends – the *Dance at Bougival* (Museum of Fine Arts, Boston), *Dance in the Country* and *Dance in the City* (both Musée d'Orsay) – which he exhibited at his first monographic exhibition of 1883. In fact, Renoir wrote in 1888 that he believed that the association between women, music and dancing dated from classical antiquity, when women 'danced to please the eye and from the sheer pleasure of being agreeable and gracious'.

Despite this perceived link, and his ambition to paint large-scale painting cycles so as to 'transform entire walls into Olympus', as Boucher had done, Renoir rarely used the female figure to allegorical ends. A number of large works painted as mural decoration in the last decades of his career, such as the pair depicting two young women selling fish and oranges, for doors in Durand-Ruel's apartment (c. 1889, National Gallery of Art, Washington), the four decorative panels known as the *Caryatids* in the Barnes Foundation (c. 1910), and the heavily swaying *Dancer with Tambourine* and *Dancer with Castanets* (National Gallery, London), painted in 1909 for the dining room of Maurice Gagnat, exploit to the full the sensual, decorative qualities of the female form and dress, without attaching any meaning or moral. The avoidance of anecdote was, in fact, central to Renoir's objectives as a painter: 'what is essential is escaping the motif, avoiding the creation of literature and thus selecting an object with which everyone is familiar – ideally, in other words, to have no story at all!'

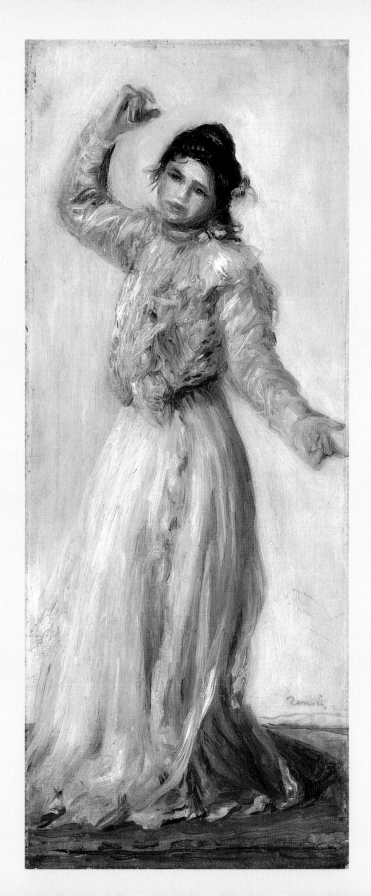

ORDINATION CEREMONY AT LYONS CATHEDRAL

HILAIRE-GERMAIN-EDGAR DEGAS

Paris 1834–1917 Paris

⌐

Oil on paper, laid down on canvas. 31.4 × 23.3 cm. Bequeathed by A. S. F. Gow
through the National Art Collections Fund, 1978. PD.11–1978

This sketch was painted on a visit to Lyons between July and September 1855. During his two months in the city, Degas made numerous drawings of its streets, quays, landscape setting and monuments – including the Gothic façade of the cathedral of Saint-Jean, and spent a considerable amount of time in the Palais des Arts, where he copied several of the paintings in the collection (see no. 22). His reasons for visiting the city are unknown, but his choice was perhaps not unrelated to the fact that his teacher, Louis Lamothe (1822–69), was at the time also in Lyons, working on the decoration of the church of Saint-Martin d'Ainay with his own master, Hippolyte Flandrin (1809–64); certainly, Degas also made copies of their work during his stay. This dramatic bird's-eye view depicts the choir of the cathedral, built between the twelfth and the fifteenth century, as seen from the triforium gallery at the west of the southern transept; in the background, a procession of ordinands dressed in surplices, approaches the archbishop's throne, with its characteristic circular steps. In the notebook that he used during his visit, Degas made specific reference to the purple colour that dominated the dais and the carpet, which is here rendered in a dark burgundy hue (Reff I: 43).

As Reff and others have noted, the plunging perspective anticipates many of Degas's later compositions, which call in to play bold perspectival viewpoints, notably those representing ballet scenes, theatrical performances or the orchestra pit that also crop the edges of the composition in the same dramatic way as he has done on the right of this painting. In one of his most audacious reuses of this steep angle of vision, *Miss Lala in the Cirque Fernando* (1879, National Gallery, London), Degas exchanged a place of worship for a place of entertainment, and reversed his own position as spectator, placing himself, as it were, in the position of an ordinand, looking up at the extraordinary feats of the glamorous acrobat.

COPY AFTER THE FINDING OF MOSES
BY PAOLO VERONESE

HILAIRE-GERMAIN-EDGAR DEGAS
Paris 1834–1917 Paris

—

*Oil on canvas. 31.2 × 17.3 cm. Bequeathed by A. S. F. Gow through
the National Art Collections Fund, 1978. PD.10–1978*

In later life, Degas famously distanced himself from his fellow Impressionists by claiming that his work, far from being spontaneous, was 'the result of reflection and the study of the Great Masters'. As a student, he first registered as a copyist at the Louvre and at the Cabinet des Estampes at the Bibliothèque Nationale in April 1853, after having graduated from the Lycée Louis-le-Grand, and also made numerous copies from commercial reproductions of paintings. His visit to Italy between 1856 and 1859 gave him the opportunity to deepen his knowledge of Italian Renaissance masters, through first-hand study of works by painters such as Titian, Giotto, Leonardo, Parmigianino, Botticelli and Bronzino.

This sketch was painted after Veronese's *Finding of Moses* (1581), which entered the collection of Louis XIV in 1685, and which is now in the Musée des Beaux-Arts in Lyons. It was made during Degas's two-month visit to the city in the summer of 1855 (see no. 21), when he made a number of other pencil sketches after other paintings in the museum, notably Perugino's magnificent *Ascension of Christ* (1496–98), originally painted for the church of San Pietro in Perugia.

Veronese was much on Degas's mind at this time. Like many nineteenth-century painters, he greatly admired the Venetian artist's use of colour and magisterial articulation of space; notebooks used between 1856 and 1860 contain several scribbled self-exhortations to emulate Veronese's subtle tonal variations, often with reference to large-scale historical paintings on which he was then working. Only a few years earlier, in 1853, one of Degas's own artistic heroes, Delacroix, described Veronese in his journal as the '*nec plus ultra* of execution', and had written admiringly of his 'verve combined with power', while in 1868, Charles Blanc, director of the *Gazette des Beaux-Arts*, wrote that the superb subtlety of his colouring made him pre-eminently 'the painters' painter'. For his part, Degas was evidently impressed by his daring, but never brash, use of colour; his palette, he noted, was 'always bold . . . and always harmonious' (Reff 1: 103).

PORTRAIT OF THÉRÈSE DEGAS, IN PROFILE TO RIGHT

HILAIRE-GERMAIN-EDGAR DEGAS

Paris 1834–1917 Paris

—

Graphite on faded pink paper. 285 × 236 mm. Verso: study of a draped male
figure, and subsidiary study of drapery, black chalk with white highlights on paper
prepared with a pink wash; inscribed: Les plis de la robe / sont très tirés,
and, lower left: manteau. Bequeathed by A. S. F. Gow through the
National Art Collections Fund, 1978. PD.24–1978

Portraiture dominated Degas's work in the early part of his career. The great majority of his sitters were friends or members of his extended family, many of whom, like Thérèse, Degas painted or drew on several occasions. As early as 1858 he was urged to pursue this genre by his father, Auguste, who insisted that, even if he himself grew tired of it, it would become the 'finest jewel in [his] crown'.

This drawing was probably made around 1855–56, before Degas left for Italy (see no. 24). The fine graphite line and use of a pinkish prepared paper ground recalls the effect, if not the actual technique, of silverpoint, a medium used extensively by early Renaissance draughtsmen such as Leonardo da Vinci and Lorenzo di Credi. In fact, from the mid-nineteenth century onwards there was something of a revival of interest in the technique, especially after the publication in 1858 of a translation of Cennino Cennini's Il Libro dell'Arte by Ingres's pupil, Victor Mottez, a treatise which Degas owned, and about which Renoir later wrote at length. In addition to a brief description of the technique, Cennini's treatise included lengthy advice on the preparation of the necessary coloured grounds, which he considered an important step in preparing the apprentice painter to work in colour.

Marie-Thérèse Flavie De Gas (1840–97), Degas's junior by eight years, is shown here aged about sixteen. In 1863 she married her cousin, Edmondo Morbilli, in Paris, and Degas went on to make several other paintings and drawings of the couple, the most remarkable of which, depicting his sister pregnant, is in the National Gallery of Art in Washington.

The study on the *verso* appears to represent a bare-footed male figure in drapery, perhaps a monk or a saint, shown with one of his feet lightly placed on a pile of books. The presence of a form of socle, or support, suggests that it may even be derived from a sculpture rather than from a painting or drawing, presumably one that Degas knew from a French collection before he left for Italy.

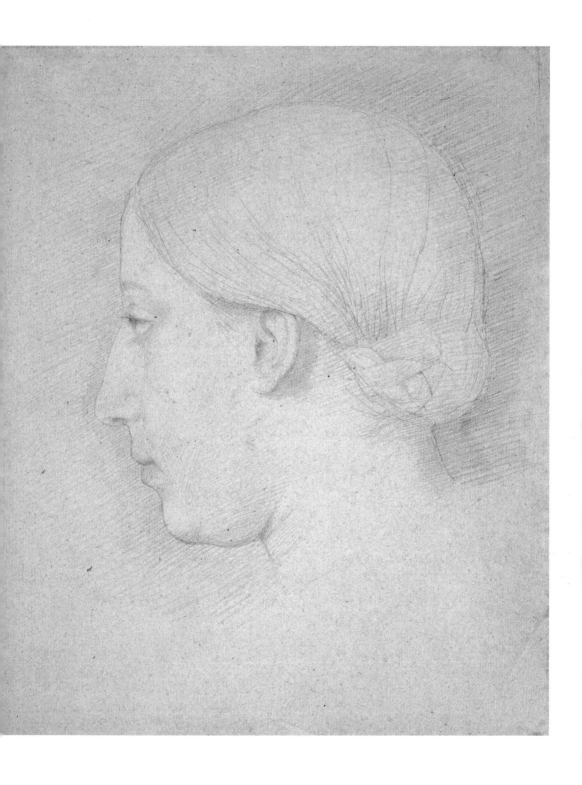

VIEW OF THE CASTEL SANT'ELMO, FROM CAPODIMONTE

HILAIRE-GERMAIN-EDGAR DEGAS
Paris 1834–1917 Paris

●

Oil on paper, laid down on canvas. 20 × 27 cm. Bought from the Gow, Cunliffe and Perceval Funds with contributions from the National Art Collections Fund and the Museums and Galleries Commission/Victoria and Albert Museum Purchase Fund.
PD.18–2000

Nothing better distinguishes Degas from his Impressionist colleagues than his dismissal of their efforts to capture the fleeting effects of nature. In later life he told the dealer Ambrose Vollard that he found the practice of outdoor painting entirely banal, and remarked, with a bluntness for which he became legendary, that the landscape painters who plagued the countryside should be treated to a round of buckshot by a specially employed police force. Pure landscapes are rare in his work, and those that aspire to any degree of naturalistic representation rarer still.

This luminous painting belongs to a small group of landscapes which he painted early in his career, during a visit to Italy between 1856 and 1859. He sailed to Naples in 1856, to stay with his grandfather and cousins, and from there made expeditions to the surrounding countryside. The view depicts the Castel Sant'Elmo and the adjacent monastery of San Martino, and may have been painted from Capodimonte, situated on a nearby hill. It relates to a watercolour sketch of the fortress that he made in one of the notebooks used during his Italian trip and to a pencil sketch drawn in September 1856, alongside which he inscribed a quote from Dante's *Purgatorio*: 'The heavens call to you and circle round you showing their eternal beauties and your eye gazes only to earth' (Reff 1: 55); interestingly, the same notebooks contain endless references to the pearly, opalescent quality of the Neapolitan sky, which he so beautifully captures in this small painting.

During his visit to the Museum in Naples, Degas had admired 'the most beautiful Claude Lorrain one can see. The sky is like silver and the shadows speak to you' (Reff 1: 53). If this painting shows the latter's influence, it is filtered through early nineteenth-century landscape painters, most notably Corot, in the astonishing subtlety of his rendering of stillness and light. In fact, Degas is thought to have met Corot later in his career, and shared the passion of his friend, Henri Rouart, for collecting the latter's early work, eventually owning seven paintings by the older painter, six of which were landscapes.

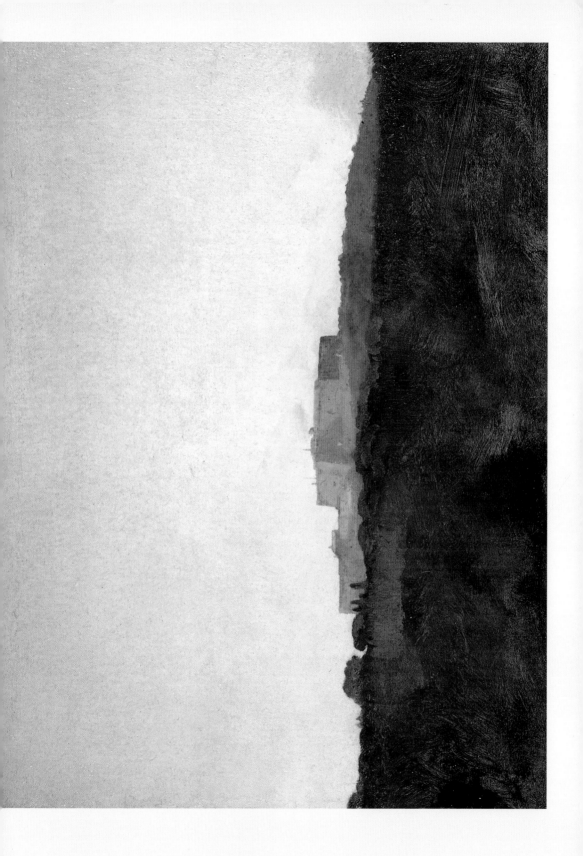

STUDY OF DONATELLO'S BRONZE STATUE OF DAVID

HILAIRE-GERMAIN-EDGAR DEGAS
Paris 1834–1917 Paris

Graphite on paper, with incised hatching on the face. 290 × 222 mm.
Verso: study in graphite of a horse's head; study of the head and shoulders of a man;
inscribed in graphite, lower left: Pb.2136 / I (?) 1794; and, verso, in blue chalk, top
right: 1794. The verso also bears the Degas studio stamp. Bequeathed by A. S. F.
Gow through the National Art Collections Fund, 1978. PD.26–1978

The statue of the young warrior hero David by Donatello (?1386–1466), one of the sculptor's most renowned works, was executed for the Medici family in Florence around 1444–46. Degas is likely to have seen it during his visit to Florence in 1858, at which time it was displayed in the Uffizi, before being moved to its present location in the Museo Nazionale del Bargello in 1865. Around the same time, Degas was exploring the subject of David's battle with the Philistine giant Goliath in a series of pencil sketches and in the oil painting that is also now in the Fitzwilliam's collection (no. 27), although no fully resolved composition appears to have emerged from these initial ideas. The fine pencil line is characteristic of Degas's early work (see also nos. 23, 26, 28). In this case – as if to emphasize its kinship to silverpoint – he has combined his work in pencil with an incised hatching in the figure's face, perhaps to emulate the texture of the face of the original or to create an equivalence for the reflections of the metal surface.

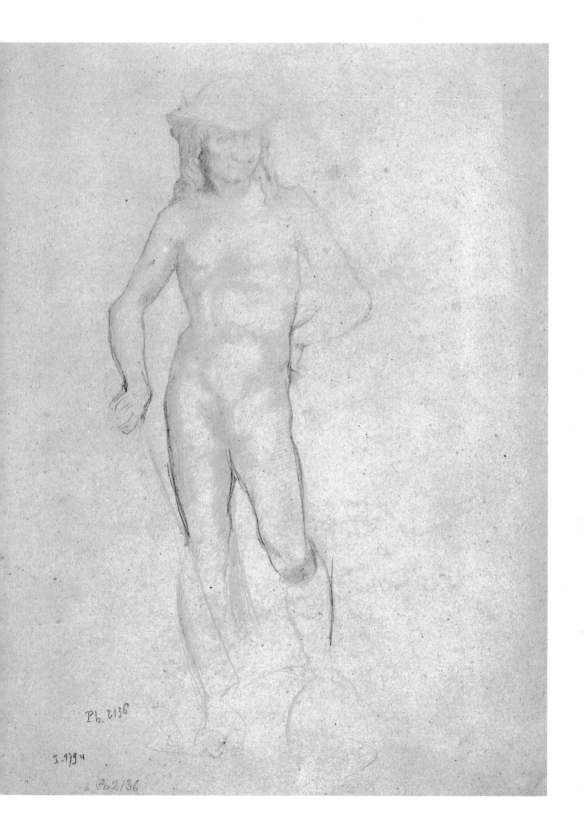

Pb. 2136

I. 1794

Pb.2136

FIGURE STUDIES

HILAIRE-GERMAIN-EDGAR DEGAS

Paris 1834–1917 Paris

•

Graphite on paper. 202 × 264 mm. Degas studio stamp, lower left.
Bequeathed by A. S. F. Gow through the National Art Collections Fund, 1978.
PD.29–1978

Like any good, academically trained student, Degas prepared for his historical compositions by making careful preliminary studies of the compositional arrangement and of the individual pictorial elements it contained. Paintings of the late 1850s and 1860s, such as the *Scene of War in the Middle Ages* (1865) and *Semiramis constructing Babylon* (1860–62), both in the Musée d'Orsay, and *The Daughter of Jephthah* at the Smith College of Art in Northampton (1859–61), for example, were all preceded by an extensive series of preliminary drawings of individual figures, groups, and of the compositional layout, which Degas used to help him assemble these ambitious, multifigured history paintings.

This drawing does not relate directly to any of his known subject paintings, although it may represent a preliminary idea which was abandoned as the composition evolved. Similar youthful figures appear in several compositions, often in pairs or groupings where one figure all but obscures an adjacent companion. The relationship between the two figures on the upper register of the sheet – the one apparently inciting or encouraging the other – tends to support Lemoisne's suggestion that it may be a model for the figure holding a coat in Degas's painting of *Alexander taming Bucephalus* (1859–61; National Gallery of Art, Washington), although it also recalls his pairing of certain figures in the background of *The Daughter of Jephthah* and, perhaps most compellingly, the two young figures cowering inside a hollowed tree trunk in an early compositional idea for *Scene of War in the Middle Ages* (1865; Louvre).

As in many of his working drawings, Degas has here omitted physiognomic details in one of the figures, his concern being to explore a possible alternative to a specific problem of figural arrangement, rather than to convey character or expression.

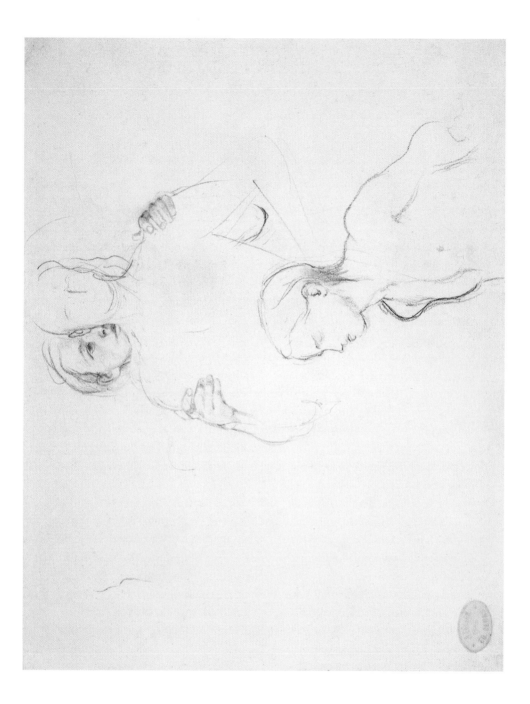

DAVID AND GOLIATH

HILAIRE-GERMAIN-EDGAR DEGAS

Paris 1834–1917 Paris

—

Oil on canvas. 63.8 × 80 cm. Bequeathed by Captain Stanley
William Sykes, OBE, MC, 1966. PD.7–1966

As a student (briefly) at the École des Beaux-Arts and a second-generation *Ingresiste*, Degas would have been keenly aware of the importance accorded to history painting in an artist's formation. His own work in this genre is largely confined to the period between 1858 and 1865, during which time he produced a small number of large-scale, multifigured compositions on themes inspired by the Bible, contemporary political events and classical antiquity.

This dynamic sketch is the most fully evolved working of a subject that Degas began to explore at the end of 1857 in pencil sketches made during his visit to Rome and Florence. Less ambitious and less finished than his other historical compositions – the figures are very summarily sketched in brown paint – it nevertheless broadly adheres to the theme of youthful figures in, or preparing for, combat which he chose for other paintings of around this date; the gesture of David's raised arm, in particular, recalls that of a soldier in *The Daughter of Jephthah* (1859–61, Smith College of Art, Northampton, Mass.). That the figure of the valiant warrior youth was much in his mind at the time is evident both from the pencil copies he made after Donatello's bronze statuette of David in Florence (see no. 25), and, in a notebook used in Rome, after Bernini's dynamic marble sculpture in the Borghese gallery.

Although Degas had, in Jacques-Émile Blanche's expression, 'drunk of the manna of Ingres', it in no sense diminished his admiration for the latter's great rival, Delacroix, many of whose works he copied. Around the time he made this sketch, he copied several of the works that Delacroix had submitted to the Salon of 1859, which critics described as having the harmonious but faded colouring of worn tapestries. The sharp twist of David's body towards the distant horizon, and his victorious arm gesture also compellingly recall – in reverse – those of the shipwrecked sailor in Géricault's *Raft of the Medusa* (1819), which Degas would have known from his visits to the Louvre.

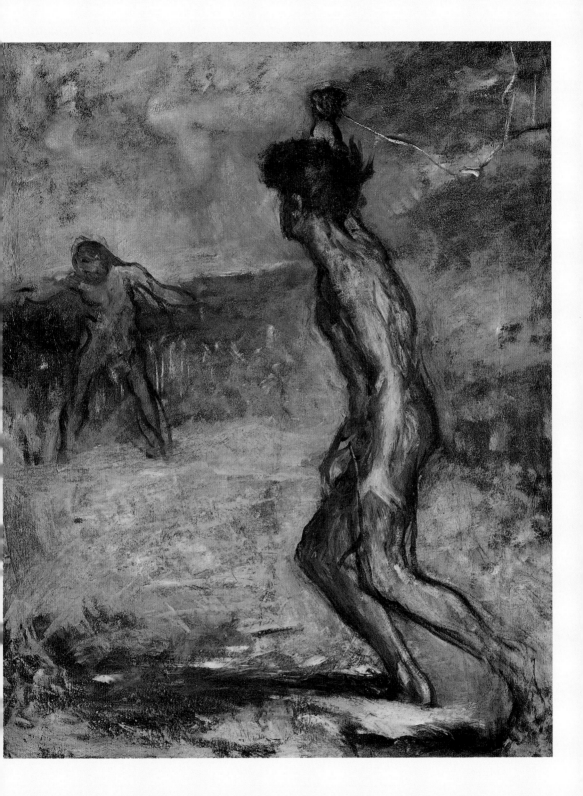

STUDIES AFTER G. B. FRANCIA'S MADONNA AND CHILD WITH SAINTS AND MADONNA AND CHILD BY A FOLLOWER OF LEONARDO DA VINCI

HILAIRE-GERMAIN-EDGAR DEGAS
Paris 1834–1917 Paris

—

Graphite with traces of red crayon on paper, laid down. 262 × 340 mm.
Verso: Degas studio stamp. Bequeathed by A. S. F. Gow through
the National Art Collections Fund, 1978. PD.30–1978

These studies were made after two paintings now in the National Gallery in London: on the left, Francia's *Madonna and Child with Saints*; on the right a Madonna and child by a follower of Leonardo. Both were among the forty-six paintings acquired by the National Gallery in January 1860 from Edmond Beaucousin, a friend of Degas's father, whom Degas had met on several occasions. The collection was first seen in Paris by the keeper of the National Gallery, Ralph Wornum, in 1857, at which stage Beaucousin was unwilling to part with any of his paintings; around two years later, however, Beaucousin seems to have relented, and the collection was officially acquired by Eastlake for the gallery.

This drawing was presumably made in Paris after Degas's return from Italy in April 1859, and before the paintings left for London in February 1860. Beaucousin appears to have been interested enough in the artistic progress of his friend's son to visit him during his stay in Florence in 1858; from a notebook which Degas used in Paris, they appear to have been in contact again after his return. A faintly tetchy reminder regarding an idea for a portrait of his brother René, scribbled in one of his notebooks, suggests that Degas did not always appreciate Beaucousin's intervention: the portrait would, he wrote, be, 'very gracious and simple . . . despite Mr Beaucousin' (Reff 1: 8).

Degas needed no encouragement to copy the works of the masters of the Italian Renaissance, and had a particular admiration for the Italian primitives' ability to represent 'the gentleness of lips by imitating them with hard lines and make the eyes come to life by cutting the lids as if with a scissors'. It may be that, in this case, Degas was eager to record two of the finest paintings in Beaucousin's collection before their imminent departure for London.

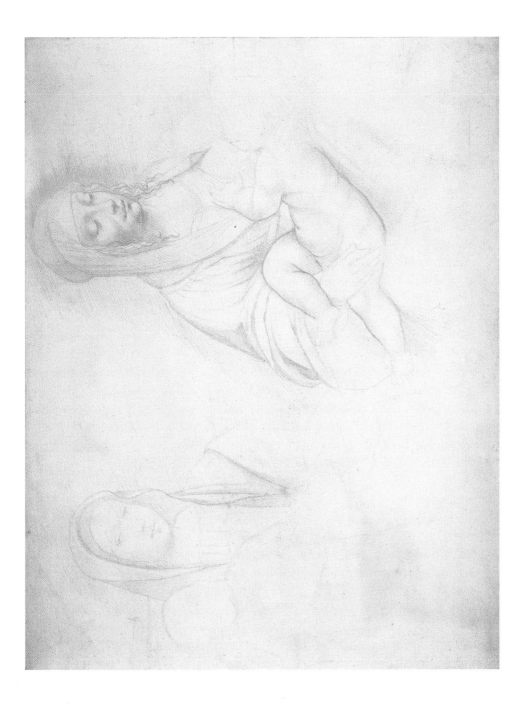

ROCKS AT BAGNOLES-DE-L'ORNE

HILAIRE-GERMAIN-EDGAR DEGAS
Paris 1834–1917 Paris

•

Watercolour, brown ink and graphite with gum arabic on paper. 255 × 200 mm.
Bought 1951. PD.10–1951

From 1861, Degas made regular visits to the country estate of his schoolfriend, Paul Valpinçon, at Château de Ménil-Hubert, in Normandy, in order to 'drink in some green'. A confirmed city-dweller, who frequently proclaimed his near allergy to the countryside, he later confided to Henri Rouart that, during the first days of his visits he 'felt stifled and dazed by the amount of air'.

This landscape was probably painted around 1867. Degas made sporadic use of watercolour in the late 1850s, notably during his visit to Italy, but used it here for the first time in over a decade; in his later years he came to consider it 'thin' and abandoned it almost completely as a drawing medium in favour of charcoal and pastel. As his subject, he has chosen a 'landscape' and a viewpoint apparently deliberately so as to deny any possibility of picturesque handling. As Richard Kendall has pointed out, this sheet, and a watercolour of the same subject in the Musée d'Orsay, which originally formed part of the same lot in the artist's sale, seems to have been executed consciously in the spirit of Courbet (Kendall 1993: 77). Degas would certainly have known Courbet's landscape paintings from exhibitions in Paris, such as those exhibited at the Exposition Universelle and at his one-man exhibition of 1855.

As a medium, painters generally favoured watercolour for its transparency and luminosity, and many treatises published in France in the nineteenth century recommended it for precisely these qualities, often praising the technical prowess of the English watercolour school. Degas's idiosyncratic use of the medium here, on the other hand, demonstrates his technical inventiveness and 'lack of formulae' with which Jacques-Émile Blanche later characterized his work. The palette of earth colours in greens, greys and browns creates an image of such substance and density that it has often been thought Degas incorporated oil paint into the watercolour base; in fact, he has used gum arabic to darken the shadows, and in some places even manipulated the paint surface with his fingers.

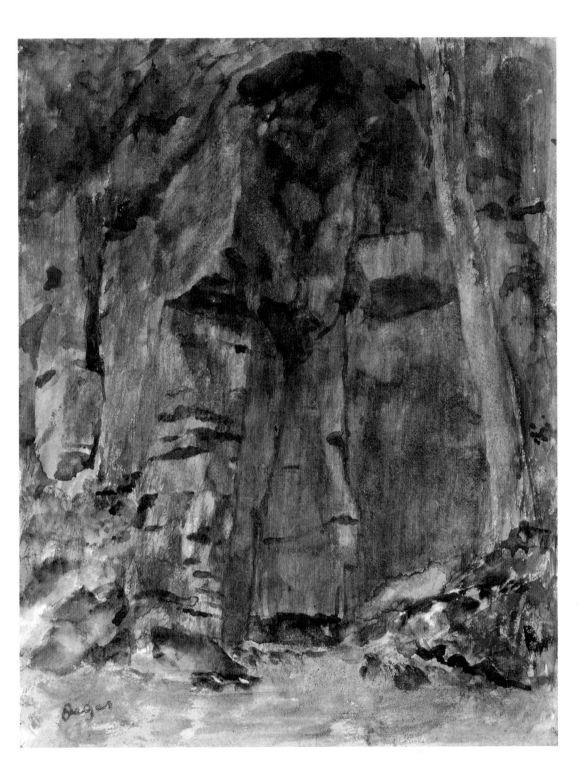

STUDIES OF A PONY

HILAIRE-GERMAIN-EDGAR DEGAS
Paris 1834–1917 Paris

•

Graphite on paper. 285 × 190 mm. Degas studio stamp, lower centre.
Bequeathed by A. S. F. Gow through the National Art Collections Fund, 1978.
PD.27–1978

Degas's interest in depicting horses and their mounts was probably stimulated in 1861 by a visit to the Normandy home of his friend Paul Valpinçon, with whom he followed steeplechase and attended the racetrack. He exhibited his first racecourse painting – *Scene from the Steeplechase: the Fallen Jockey* (National Gallery of Art, Washington) – five years later, at the Salon of 1866.

His many studies of horses – placidly grazing, as here, or in full gallop at the racecourse – show how thoroughly he studied equine anatomy. In the late 1850s he began to make copies after the *écorché* drawings of another great French painter of the horse, Théodore Géricault, and owned a set of the latter's lithographic series, *Études de chevaux*, published in 1823; as Jean Boggs has recently suggested, he may also have referred, some years later, to photographs such as those in Louis-Jean Delton's *Album hippique* (1998: 82). Although in no sense a horseman himself, horses feature in all but one of Degas's early history paintings, and in the latter half of the 1860s his earliest essays in sculpture – an entirely personal exercise which he used to 'warm himself up' – were also explorations of the equine form.

Similarities with studies in notebooks in the Bibliothèque Nationale (Reff I: 112, 121–2) and in the Musée d'Orsay suggest that this sheet was executed around 1871. Like these, it may be a study for the painting *Two Horses at Pasture*, which Lemoisne has dated to this year. As Degas was in Ménil-Hubert for a short time after the proclamation of the Commune in March 1871, it could be that this sketch was made during this two-month visit to Normandy. Later that year Degas visited London, apparently for the first time. Like Géricault, he recognized that the English passion for racing was likely to ensure a ready market for his work, and chose the theme of the racecourse for five of the six paintings he sent to his first London exhibitions, in 1872 and 1873.

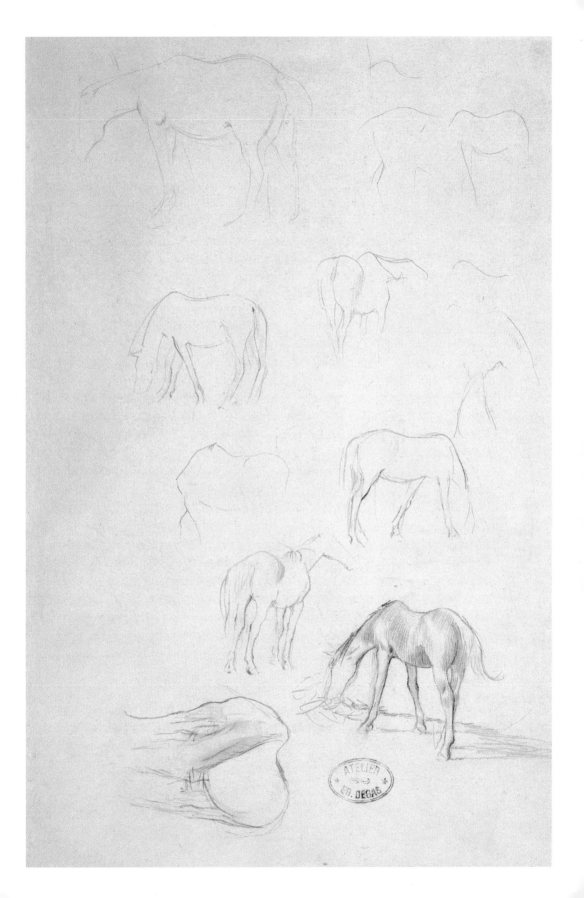

PORTRAIT OF ELISABETH DE VALOIS,
AFTER ANTONIS MOR

HILAIRE-GERMAIN-EDGAR DEGAS
Paris 1834–1917 Paris

-

*Black chalk, charcoal and stump on laid paper, laid down. Watermark:
J. Iversay. The number 2 incised on the sheet. 405 × 274 mm.
Bequeathed by A. S. F. Gow through the National Art Collections Fund, 1978.
PD.22–1978*

This beautiful drawing is a copy of a portrait of Elisabeth of Valois (1545–68), daughter of Henri II of France and the Queen of Spain, by the Flemish portrait painter Antonis Mor (1517–75). Mor's original portrait, painted in 1560, shows her in sumptuous court dress, with an elaborate, jewel-encrusted headdress. Significantly, Degas has chosen to avoid all of these decorative details and to concentrate instead on the sitter's features and the intensity of her expression. By doing so, he underlines its similarities with the open features and firm gaze that characterize many of his female portraits of the late 1850s and 1860s, notably those of his immediate family (see no. 23).

A number of versions of the painting exist, although it is uncertain which of these Degas used to make this copy. The most likely candidate would appear to be that exhibited in Brussels in 1873 by its owner, John W. Wilson, who afterwards lived in Avenue Hoche, Paris. Despite appearing in a volume of etchings by Jules Jacquemart illustrating paintings acquired by the Metropolitan Museum of New York, and published in 1871, the portrait appears to have passed from Wilson to the banker Ferdinand Raphaël Bischoffsheim (who also owned paintings by Degas); it was last recorded in a private collection in the Netherlands. The suggestion that Degas based his copy on Jacquemart's etching is less convincing, as its fine intaglio line would seem an improbable source for the rich chiaroscuro effects and fleshy bloom which Degas has so brilliantly reproduced in this drawing; details such as the pronounced flounces of the lace collar and the modelling of the nose also suggest that he worked from the painting rather than from the print.

This drawing has been dated between 1865 and 1870 on stylistic grounds, although this accords neither with the date of Jacquemart's etching, nor with the possible dates at which he might have seen the Wilson painting. Degas recorded Wilson's name and address in a notebook that he used in Paris between 1879 and 1882, possibly as a reminder to view the sale of Wilson's collection there in 1881 (Reff 1: 138).

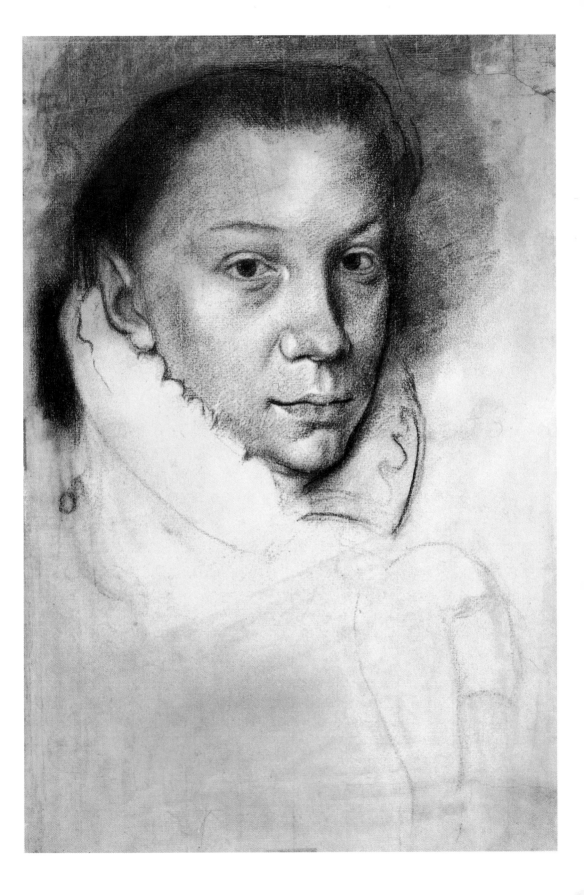

PORTRAIT OF THE DANCER JULES PERROT

HILAIRE-GERMAIN-EDGAR DEGAS
Paris 1834–1917 Paris

‒

Black chalk heightened with white chalk on faded pink paper. 470 × 312 mm.
Inscribed in chalk, upper right: Reflet rouge de la / chemise dans le cou / pantalon
bleu / flanelle / tête rose; and, verso, in blue chalk: Pb [h ?] 651; and, in black chalk:
2855; 2. Degas sale stamp, lower left. Bequeathed by A. S. F. Gow through the
National Art Collections Fund, 1978. PD.25–1978

Jules Perrot (1810–92) was one of the leading male dancers and most influential choreographers of the Romantic era. He first danced at the Paris Opéra in 1830, and became renowned for his ballet *Giselle*, choreographed for Carlotta Grisi. From 1848 to 1861 he worked as artistic director at the Bolshoi Theatre in St Petersburg; when he returned to Paris, his style was considered outdated, but he continued to give a few highly prized classes. His imperfect physical form did nothing to diminish his success; although he was considered ugly, he was said to be 'from the waist downwards delightful to look at'.

This is a study for Degas's painting *The Dance Class* in the Musée d'Orsay, Paris, begun in 1873 and completed between 1875 and 1876. In 1874, having temporarily abandoned work on this version, Degas completed a very similar painting for the baritone Jean-Baptiste Faure (Metropolitan Museum of Art, New York; see no. 8), in which he altered the position of some of the dancers and made subtle variations to Perrot's pose.

An x-ray of the Paris painting has shown that considerable modifications were made to the composition as work progressed, notably to the figure of the dance master, who was originally depicted as a younger man, viewed from behind. The decision to transform this figure into a portrait of Perrot was thus made after the composition was begun, and it is likely that Perrot – who it is far from certain would have been giving classes at the time – posed for Degas for this purpose in 1874.

The colour notes on this drawing accord directly with the version of the painting in the Musée d'Orsay, in which the brilliant red of Perrot's shirt appears at the collar, and his trousers are blue, as opposed to the beige pair he sports in the New York picture. Probably drawn from life, it served as the model for a more colourful portrait in *essence*, now in Philadelphia Museum of Art, signed and (possibly erroneously) dated 1875, whose more summary nature and concessions to the aging dancer's features and *embonpoint* suggest that it was made in the studio on the basis of this drawing.

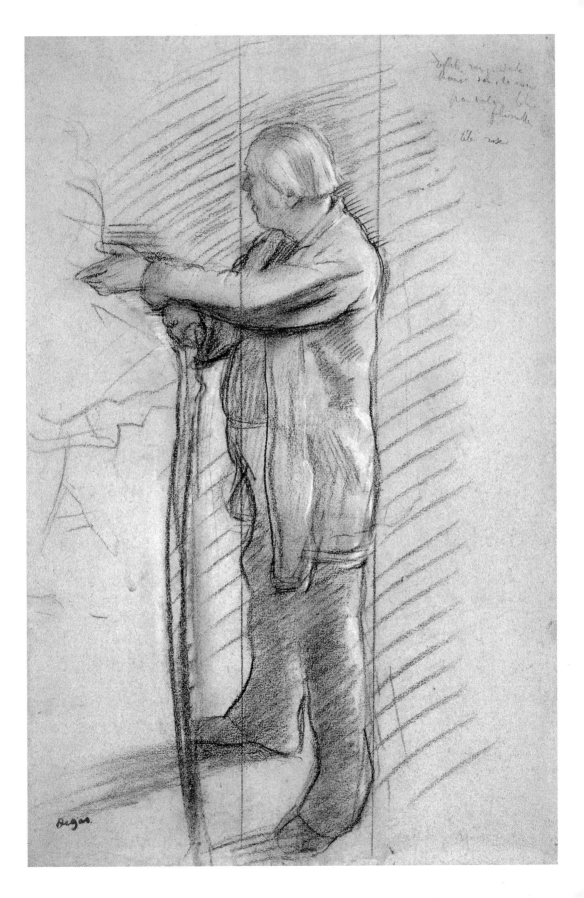

AT THE CAFÉ

HILAIRE-GERMAIN-EDGAR DEGAS
Paris 1834–1917 Paris

Oil on canvas. 65.7 × 54.6 cm. Signed, lower right: Degas.
Bequeathed by Frank Hindley Smith, 1939. No. 2387

Degas frequently represented his figures as stationary, immobile, and often pensive. Dancers behind the scenes, their chaperones waiting during rehearsals or performances, women sulking, prostitutes between clients, opera-goers idling in backstage corridors: all represent the prelude, *entreacte* or sequel, rather than the action itself.

This is one of a number of scenes of women in cafés which Degas represented in paintings, drawings and prints between 1875 and 1877. The best known of these is his painting *At the Café*, familiarly known as L'*Absinthe* (1876, Musée d'Orsay), but he also produced a remarkable series of monotypes, many heightened with pastel, depicting prostitutes in cafés or in brothels. In one of these, *Women on the Terrace at a Café, Evening* (c. 1876–7, Art Institute of Chicago), Degas included two women in conversation, one of whose faces is obscured by a pillar; he later sent an impression of the same monotype, reworked in pastel (Musée d'Orsay), to the Impressionist exhibition of 1877. The red touches on the tablecloth also recall a monotype reworked in pastel in a private collection in New York (c. 1877; Janis 1968: 59), in which the woman is shown playing with a pack of cards.

The two women in this painting have sometimes been described as prostitutes, their unchaperoned presence in a public place signalling their availability to a prospective male clientèle. If their identities and activities remain elusive, it may be because, in the context of the painting, they are of secondary importance; instead, Degas seems to have been more concerned to evoke – as he was in another painting of this date, *At the Racetrack* (Eugene Thaw collection, New York) – the intimate, apparently troubled, nature of the dialogue which consumes them. Any narrative is internal, and is made all the more disturbingly ambiguous by obscuring the two women's faces and expressions. His stance is neither moral nor sentimental, but no less humane for that; as Renoir later commented, Degas's representations of prostitutes were instead distinguished by, 'that chaste, half-religious side, which . . . is at its best when he paints those poor girls'.

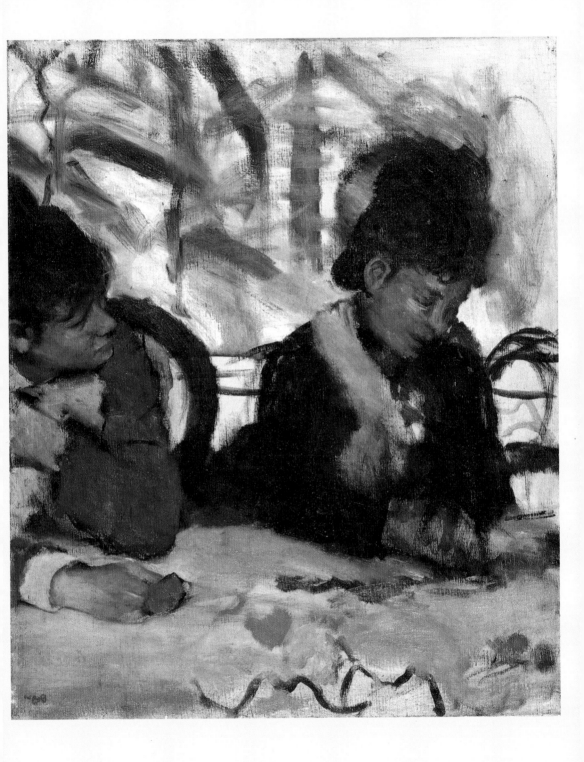

GIRL DANCER AT THE BARRE

HILAIRE-GERMAIN-EDGAR DEGAS
Paris 1834–1917 Paris

—

*Black chalk on pink laid paper. 340 × 240 mm. Inscribed in black chalk, upper
right: ronds de jambe à terre; and, by Henri Rouart, in brown ink, upper right:
Dessin de Degas / H. Rouart. Bequeathed by A. S. F. Gow through the
National Art Collections Fund, 1978. PD.32–1978*

As a number of authors have shown, Degas's paintings of the ballet on stage and off are
not factual records, but rather creative, and retrospectively seamless, combinations of the
real and the invented. His representation of ballet positions and movements, on the other
hand, was exceptionally accurate, and in his many studies of dancers exercising, including
the present charming example, Degas was able to carry out a form of visual rehearsal so as to
fix with precision the specific demands of the individual dance positions. This is one of
three drawings of the same young dancer, Suzanne Mante, one of the three daughters of
Degas's one-time neighbour, Louis-Amadée Mante, who played the double-bass for almost
half a century at the Opéra. Each is similar in size, drawn on a pink paper, and annotated
with a description of the position that the young dancer assumes. In this case, she is shown
performing a *ronds de jambes*, a ballet exercise in which the leg is rotated from the hip, with
the foot either on the ground or in the air; other drawings in the Metropolitan Museum of Art
in New York, and another sold in Paris in 1944 (Browse 1949: fig. 76) show her – again at the
barre – practising, respectively, her *grands battements*, with the right leg, and the *battements en
pointe*. The figure is not related to a specific painting, however the apparent age of the sitter
suggests a date of 1878–80.

The incipient adolescent girl dancers known as the ballet 'rats' were generally from
poor backgrounds and more often obliged to find an alternative means of supplementing
their meagre income through the favours of wealthy male admirers. As Kendall has shown,
however, by no means every dancer turned to prostitution: Suzanne Mante, for example, like
her sister, rose through the ranks of the *corps de ballet* and eventually became a dance instructor
(Kendall 1998: 2).

This drawing first belonged to Degas's friend, Henri Rouart (1833–1912), a wealthy
engineer and painter who himself sent works to several of the Impressionist exhibitions.

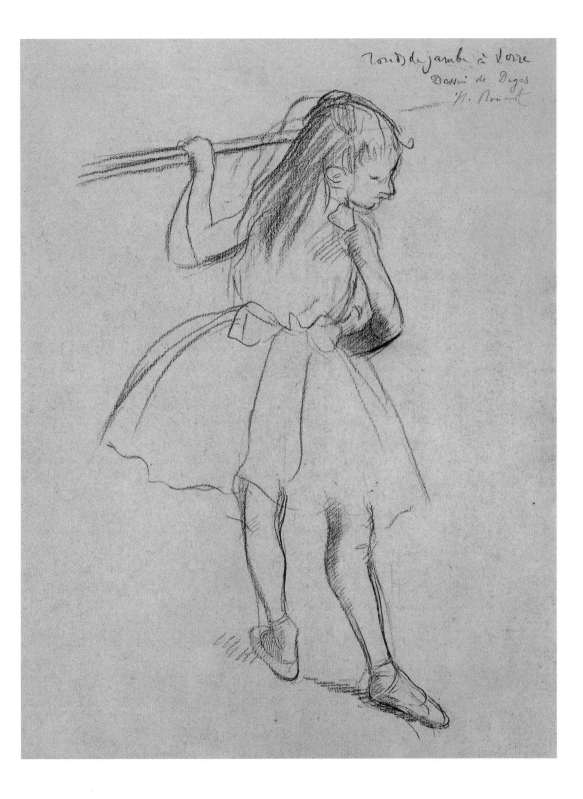

Tour de jambe à terre
Dessin de Degas
N. Rouart

YOUNG FEMALE DANCER ADJUSTING HER TIGHTS

HILAIRE-GERMAIN-EDGAR DEGAS

Paris 1834–1917 Paris

◦

Graphite, black chalk and white highlights on laid paper, squared with charcoal
for transfer. Watermark: L. Berville. 242 × 313 mm. Signed in black chalk,
lower right: Degas. Bequeathed by A. S. F. Gow through the
National Art Collections Fund, 1978. PD.23–1978

Degas made many drawings of dancers in this pose. The earliest was probably drawn around 1879, and relates to a painting entitled *The Dance Lesson* (c. 1880, Sterling and Francine Clark Institute, Williamstown, Mass.), one of the first ballet scenes for which Degas adopted an extended horizontal compositional format. This drawing is thought to date from the same period; however, the position of the dancer's head, leg and tutu relate more closely to another composition in a similar format, *Ballet Rehearsal* (*La salle de danse*; Yale University Art Gallery), which Degas painted at least five years later. It may have been that Degas chose to modify the more pronounced horizontal emphasis of the dancer's leg in the earlier version by raising it at a slight angle. This apparently insignificant alteration nevertheless has the effect of heightening the tension of the dancer's pose, and with it the overall dynamic of the composition.

One of the most striking features of Degas's later drawing style is the liberty with which he not only reworked formal elements within similar compositional themes, but also integrated them into surprisingly diverse contexts. This tendency is particularly marked in the series of monotype landscapes that he made at the beginning of the 1890s, in which, with the addition of pastel, the tumbling hair of a recumbent female nude is transformed into a cliff face and isolated rocks and dolmen in an open landscape assume unmistakably phallic form. In this case, as Richard Kendall has shown, Degas's astonishing powers of imagination allowed him, after an interval of several years, to rework the distinctive shape of the dancer's slim, muscular leg into a long spur of land in a pastel monotype of around 1890–92 (1994: 42). With each of these startling transformations, Degas asserted the independence of form over the motif: as he commented some years later to his fellow-Impressionist, Jean-Louis Forain: 'Ah, my noble friend . . . what things one can say with a drawing!'

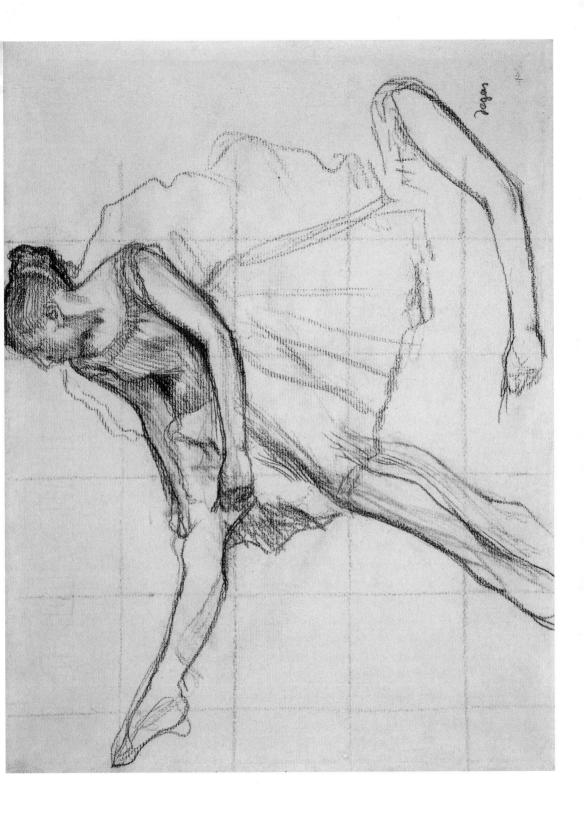

AFTER THE BATH

HILAIRE-GERMAIN-EDGAR DEGAS
Paris 1834–1917 Paris

—

Charcoal on yellowed tracing paper, laid down. 360 × 270 mm, irregular.
Bequeathed by G. J. F. Knowles, 1959. PD.37–1959

Drawing and painting from the female nude formed an integral part of the French academic painting tradition in which Degas was trained. For his subject paintings of the 1850s and 1860s, he made a number of preparatory studies of the female nude, partly in order to help him construct his final composition, but in the 1880s and 1890s he began to make series of independent studies of the nude, mostly representing his models engaged in activities of uncompromising banality: washing, drying, yawning, squatting, combing their hair and picking their feet. His most thorough exploration of the theme was in a suite of ten (possibly fewer) pastels that he exhibited at the last Impressionist exhibition in 1886, in which his models appear in a variety of unconventional poses – their faces in each case obscured – vigorously rubbing themselves, or standing feet akimbo, hands on solid haunches. The suite attracted particularly virulent criticism from some commentators, who considered them scabrous, cynical and bestial, although few denied the sheer power of Degas's draughtsmanship.

This is one of a group of seven charcoal drawings showing the model from behind, drying her extended right arm with a towel. Its date is uncertain, however similarities in handling and technique – charcoal on (now-yellowed) tracing paper – suggests a date of the early 1890s. Around this time, Degas concentrated on an increasingly limited repertoire of forms, which he continually reworked or modified in variants of a single composition. Tracing paper facilitated the transfer or reversal of the image, its very fragility emphasizing the impermanence of an individual solution and the endless interpretative possibilities of a single pose. As he famously remarked to Jacques-Émile Blanche, no form could ever be sufficiently studied; instead, the artist should 'Make a drawing, trace it, begin it again and trace it again.' Despite the notional air of realism, these drawings were, as the art critic Félix Fénéon pointed out, not made from the life; instead, he wrote, Degas's practice was to accumulate a large number of sketches, 'out of which he mines works of unquestionable truth'.

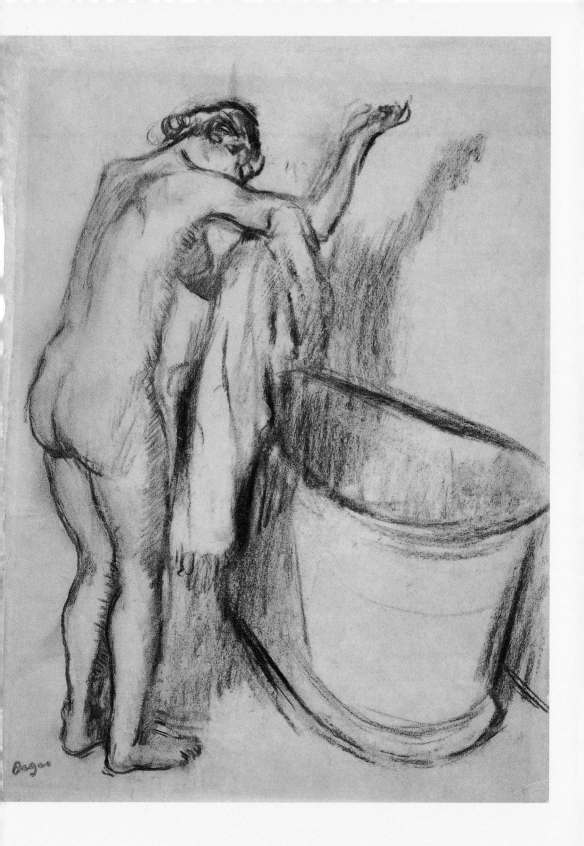

WOMAN WASHING

HILAIRE-GERMAIN-EDGAR DEGAS

Paris 1834–1917 Paris

-

Charcoal on laid paper. 318 × 248 mm. Degas sale stamp, lower right.
Bequeathed by A. S. F. Gow through the National Art Collections Fund, 1978.
PD.33–1978

Degas painted and drew women bathers from his youth. In 1855 he saw and made a pencil copy of Ingres's famous *Valpinçon Bather* (1808, Louvre), which was lent to the Exposition Universelle that year by the father of his schoolfriend, Paul Valpinçon. In later life he appears to have relished particularly the rounded form of the female back, becoming enraptured by the uncovered shoulders of his hostess at a dinner party, and nicknaming splinters of stone which he collected in the street, the 'cape of the beautiful shoulder'.

Executed around 1890, this drawing does not appear to be directly connected with any of Degas's known paintings, pastels or lithographs of women washing or bathing. These late images of models intimately posed with draperies, tin baths and tables as studio 'props' were to a great extent influenced by his knowledge of Japanese woodblock prints of the same subject, which became readily available in France from the mid-nineteenth century. In fact, Degas owned and hung above his bed in the last decades of his life a colour woodcut diptych entitled *The Bath House* by the Japanese printmaker Torii Kiyonaga (1752–1815), one of only two known impressions of this print, whose rarity may have been explained by a prurient reaction to the uncompromising nudity of the figures represented.

Like these, Degas's representations of women washing were explicitly associated with the activities of the brothel, and would have been recognized as such by his contemporaries. As Eunice Lipton pointed out, bathing was not common at the time, and was even considered to contain inherent dangers to the health (1986: 184). Brothels and *maisons closes*, themselves established out of a concern for hygiene, so as to segregate and contain prostitution, were an exception to this rule, where careful washing was essential to avoid venereal disease.

This drawing, like no. 39, was bought by the art critic Félix Fénéon from the Degas sale in 1919.

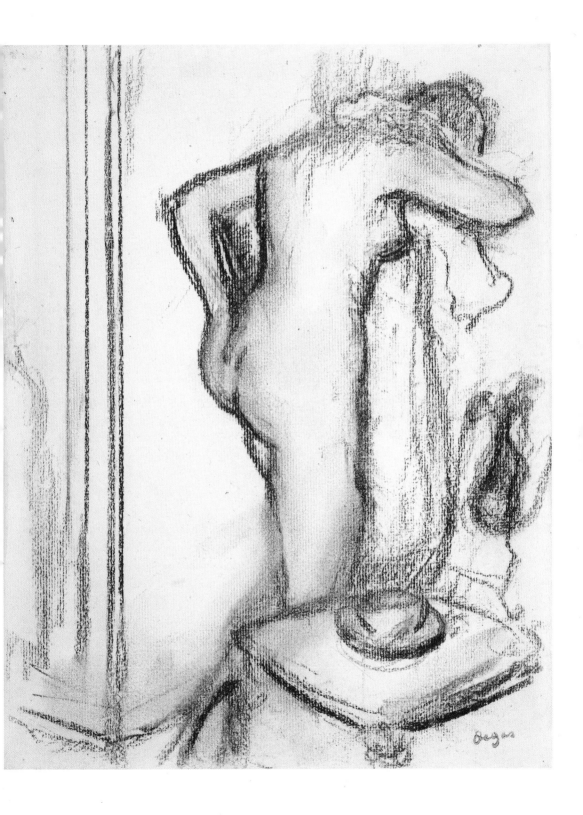

FEMALE DANCERS IN VIOLET SKIRTS, THEIR ARMS RAISED

HILAIRE-GERMAIN-EDGAR DEGAS
Paris 1834–1917 Paris

─

Pastel and black chalk, perhaps with gouache over charcoal on two sheets
of tracing paper joined together, laid down on paper. 909 × 521 mm.
Accepted in lieu of estate duty by Her Majesty's Treasury and
allocated to the Fitzwilliam Museum, 1979. PD.2–1979

Degas's extraordinarily inventive use of pastel has long been considered one of his greatest technical achievements. He began to use the medium towards the end of the 1850s, but only later in his career, in the late 1880s and 1890s, evolved the complex technique which gives his pastels of this date a richness and texture that his contemporaries compared to the woven layers of tapestry.

This pastel was probably drawn between 1895 and 1898, and is one of a series of at least nine large-scale compositions showing dancers in similar poses. In each of the variants Degas reworked – and sometimes reversed – the poses of the two central figures, subtly modifying the background, the angle of vision and the position of the limbs, and in some cases added a third dancer. These massive, gently swaying figures – singly static but multiply rhythmic – perfectly illuminate Degas's statement that his reason for obsessively painting the ballet was to find 'the movement of the Greeks'.

His exact mode of transforming this most friable of media into a solid, intricately woven mass remains somewhat obscure, although recent research has shown that the sequence with which he built up the layers follows well-established technical practice. In almost every case, he used a tracing paper support, laid down on a sheet of stronger white paper or Bristol board, rubbing it with pumice stone, wood-shavings or sand to give 'tooth'. He then applied pastel mixed with casein, shellac, gelatine or gum arabic, or dispersed in an aqueous substance (sometimes by blowing boiling water over the surface to create a paste); on top of this base, he worked in a series of expressive graphic gestures: striations, hatching and vigorous zig-zag markings that have been termed '*zebrures*'.

Although as a medium pastel notionally allows greater spontaneity than oil, Degas's constant reworking of the surface meant that individual compositions could take months or, as in this case, years to complete.

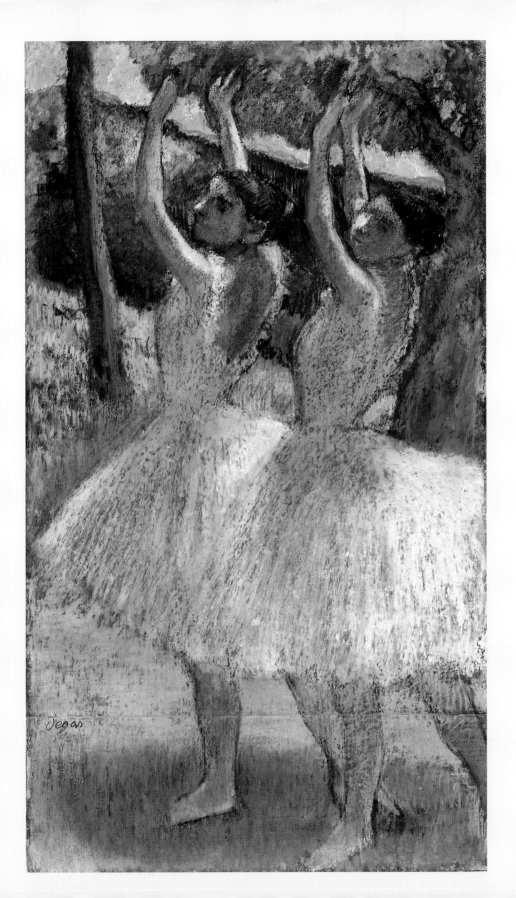

STUDY OF TWO STANDING DANCERS

HILAIRE-GERMAIN-EDGAR DEGAS
Paris 1834–1917 Paris

-

Charcoal on tracing paper. 420 × 425 mm. Degas sale stamp,
lower left. Bequeathed by A. S. F. Gow through the National
Art Collections Fund, 1978. PD.34–1978

Degas is known to have witnessed dance rehearsals at first hand, and – rather later – gained access to the backstage at the Opéra; however most of his images of the ballet were executed in the studio. Although he painted scenes from the ballet from the early 1870s, it came to dominate his subject matter in the 1890s, during which time he regularly reworked closely similar compositions in different media, sometimes over a period of up to fifteen years.

This drawing of a dancer fanning out her skirts, with another roughly sketched in behind, was probably made around 1898–1900. It relates to a number of different compositions in oil, charcoal and pastel depicting dancers in rehearsal rooms that Degas executed between around 1889 and 1910. From a lithograph made around 1889 after the painting that appears to have been the first in the series (c. 1905, E. G. Bührle collection, Zurich), it transpires that this figure was an afterthought, added after the composition was begun. Degas would thus have used this charcoal drawing not only to explore the pose of the additional figure – which assumes an important position in the foreground of subsequent compositions – but also to establish its interaction with the adjacent dancer, who is shown fixing the shoulder straps of her costume. Degas used it again in two further pastel and charcoal compositions in a similar frieze-like format, now in the Toledo Museum of Art (c. 1905) and in the Wallraf-Richartz Museum in Cologne (1905–10), probably made on the basis of tracings made from the earlier painting.

When Degas later told the dealer Ambrose Vollard that he painted scenes from the ballet so as to 'paint pretty clothes', he was being only partly disingenuous. As this drawing makes clear, the diaphanous gauze of the ballet-dancer's skirts, when translated into Degas's pictorial vocabulary, became not only a vehicle for the exploration of light and semi-transparency, but also an assertive, physique-deforming, structural element in its own right; more fully worked up in his late pastel compositions, it also allowed him to give free reign to the wildest flights of his colouristic fantasy.

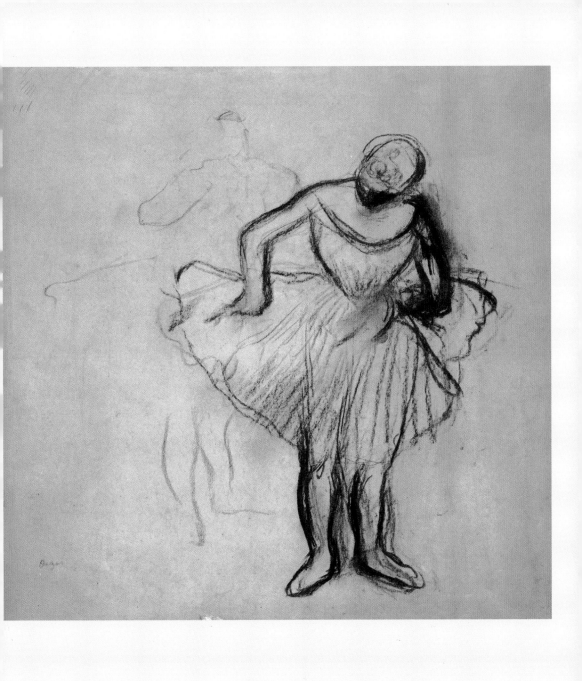

STUDY OF A STANDING NUDE WOMAN, HER LEFT ARM RAISED

HILAIRE-GERMAIN-EDGAR DEGAS

Paris 1834–1917 Paris

—

Charcoal heightened with white chalk on tracing paper, laid down. 539 × 388 mm.
Degas sale stamp, lower left. Bequeathed by A. S. F. Gow through the
National Art Collections Fund, 1978. PD.35–1978

In his work of the 1880s and 1890s, Degas moved with increasing fluency between media in order to explore the different possibilities which each brought to the treatment of a single subject. The exchange could take place not only between the traditional two-dimensional media of painting, drawing and printmaking, but also drew on his experience of sculpture and photography.

Degas began to take an interest in photography around 1895, and in the autumn of that year Julie Manet recorded that he could think of little else. This magnificent drawing, executed around 1898, relates closely to a photographic negative of a dancer holding a screen, probably made three years earlier. The dramatic reverse lighting effects of the negative are reproduced in this drawing in the deep shadow cast over the dancer's face and in the boldly drawn striations of white highlights on her cheek, shoulder and arm. Although the authorship of the photograph has been disputed – many other people in Degas's circle were experimenting with the medium at the time – it has recently been argued persuasively that, as the relevant negatives were found in Degas's studio on his death, they are more likely to have been made by him than by anyone else. In fact, Degas became aware of the importance of introducing a variety of light effects from early in his career, reminding himself, in a notebook used between 1868 and 1872, to exploit them in his work, as 'this part of art can today also become immense' (Reff I: 117).

The pose itself reworks, with modifications, that of the female figure, bound by her left arm to a tree, in an early historical composition, *Scene of a War of the Middle Ages* (Musée d'Orsay), which he exhibited at the Salon in 1865, a painting which remained in his studio until his death. He repeated it in two other drawings contemporary with this sheet, each of which depicts the model clothed, and as the left-hand figure in a superb, brilliantly coloured pastel in the Pushkin Museum of Modern Art, Moscow, also made around 1898.

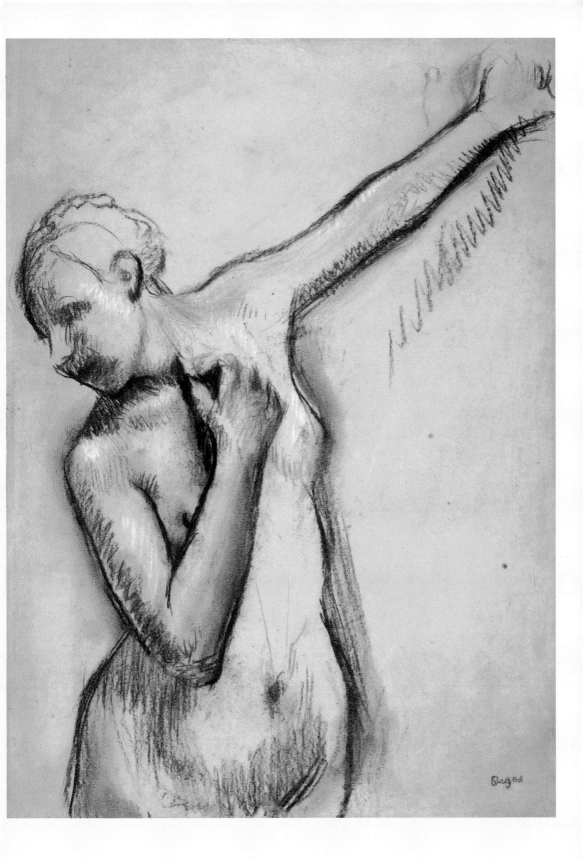

STUDY FOR THE BANKS OF THE MARNE

CAMILLE PISSARRO

Charlotte Amalie, St Thomas 1830–1903 Paris

Oil on panel. 24.4 × 32.4 cm. Signed, lower right: C. Pissarro.
Bought from the C. C. Mason Fund, 1964. PD.23–1964

Pissarro took up painting in his mid-twenties, on settling definitively in Paris after a youth divided between France and his native island of St Thomas in the Caribbean. Having decided to specialize in landscape painting, he looked to the example of the most innovative practitioners of the genre, Daubigny and Corot, both of whom had a marked influence on his early work. This sketch, painted on a wooden panel, was formerly known as 'The Towpath' and was thought to represent a scene near Bougival on the Seine. It relates to a larger painting of the same subject in Glasgow Art Gallery and Museums, which Pissarro may have exhibited at the Salon in 1864, and most probably represents a view of the banks of the Marne, to the south-east of Paris; certainly, at the time, Pissarro was living at Varenne-Saint-Maur, on the Marne, and gave his address as 'care of D. Deshayes, on the water's edge'. By using a preparatory oil sketch, made out-of-doors, to elaborate a finished 'exhibition' painting in the studio, Pissarro followed entirely in a tradition of French landscape painting that was practised not only by his immediate predecessors, Corot included, but also, in his early years, by contemporaries such as Monet. In fact Pissarro, who met Corot in 1856 and who owned two of his drawings, made no secret of his debt to the older painter, exhibiting at the Salon in both 1864 and 1865 as 'a pupil of Corot'. Here, the cool palette and vivid red accent in the figure, the compositional format and the motif of a receding path, streaked with sunlight, are all characteristic features of Corot's work, itself influenced by the example of seventeenth-century Dutch painters such as Meindert Hobemma (1638–1709).

Although the finished painting is identical in composition in all but a few minor details, principally the figures, the lively brush strokes and strong colour contrasts of this sketch are toned down, creating – as Richard Thomson has remarked – a calmer mood and sense of timelessness (1990: 13).

HAYMAKING

CAMILLE PISSARRO

Charlotte Amalie, St Thomas 1830–1903 Paris

—

Oil on canvas. 45.5 × 54.8 cm. Signed and dated, lower left:
C. Pissarro 1874. Bequeathed by A. J. Hugh-Smith through
the National Art Collections Fund, 1964. PD.16–1964

This scene has been identified as the countryside around Éragny-sur-Epte in Normandy, where Pissarro settled in 1884 (see nos. 45, 49). However, in 1874, the date inscribed on this painting, Pissarro was based at Pontoise, about 25 km north-west of Paris, having moved there to take up residence for a second time in the late summer of 1872.

Stylistically, too, the paint handling and cool palette of soft pastel tones seem closer to Pissarro's work of the mid-1870s. In May 1873, Pissarro wrote to his friend Théodore Duret to say he was planning to paint a field of ripe wheat during the summer, but cautioned him not to expect a highly coloured picture, as nature was 'colourful in winter and cold in summer'. The resulting painting – *The Haystack, Pontoise* (1873, Archives Durand-Ruel) – like this painting, shows the cool, bleaching effect of the summer sun, transcribed by a palette which was, in Pissarro's own words, chalky and predominantly whitish.

Pissarro experimented considerably with his technique in the years between 1874 and 1876, during which time his palette became more sombre and dominated by earth tones (see no. 43). This painting, on the other hand, seems to be more clearly related to the optimistic mood of open summer landscapes of the agricultural plain of the Vexin, executed slightly earlier, around 1872–73, such as *The Haystack*, mentioned above, the *Landscape with a Harvest Scene, Pontoise* (1873, private collection, Chicago) and *Spring Morning, Pontoise* (1874, private collection, London), all of which are painted using a similar airy palette of soft blues and greens. Whatever the precise geographical location, Pissarro's pleasure in the manipulation of the paint – notably the play of greens and blues – is evident. It was this engagement with the sheer physicality of his medium which led the English painter, Walter Sickert, to remark that Pissarro was 'the painter for those who look at, rather than for those who read about, painting'.

PIETTE'S HOUSE AT MONTFOUCAULT: SNOW EFFECT

CAMILLE PISSARRO

Charlotte Amalie, St Thomas 1830–1903 Paris

•

Oil on canvas. 60 × 73.5 cm. Signed and dated, lower right: C. Pissarro 1874.
Bequeathed by Captain Stanley William Sykes, OBE, MC, 1966. PD.10–1966

Ludovic Piette-Montfoucault (1826–78) was a painter and close friend of Pissarro from the early 1860s. The two men may have met in the Atelier Suisse (see no. 52), or through the painter Antoine Chintreuil. Piette first sent paintings to the Impressionist exhibition of 1877, and his work was also included posthumously in the exhibition of 1879 (he had died from cancer the previous year).

Pissarro first visited Piette on his estate at Montfoucault in Mayenne (eastern Brittany) in the 1860s, but it was not until the mid-1870s that he used it as the focus for a series of extended painting campaigns. As early as 1871, Piette had encouraged Pissarro to visit him on his farm: 'What splendid things to do . . . in these places one could think that one is thrown 1,000 or 2,000 years back: no traces of man left, it is just as wild after a century or two of flood; trees and rocks of such colour'. Shortly before leaving for Montfoucault on a visit there in the autumn of 1874, Pissarro wrote to his friend of his pleasure in anticipating travelling to a region where he would find 'the true countryside'. This view is one of eighteen depicting Piette's immediate surroundings and its inhabitants that he painted during this trip, and one of five that show the effects of snow. Like others in the group, it focuses on the house and outbuildings; although unpeopled, it bears unmistakable traces of human presence in the melting tracks in the snow.

Pissarro was a superb painter of snow and frost. He relished its luminosity and changing hues, and the distinctive forms which the landscape assumed under a rigid blanket of frost; in fact, a scene of hoar frost (1873, Musée d'Orsay) was among the five paintings he sent to the first Impressionist exhibition, in 1874. Comparison with a later snow scene (no. 45) shows how he varied his palette to register the snow-covered landscape under different weather conditions, from the warm mauve undertones of freshly fallen snow in sunlight to the chill, slate-grey earth colours where the snow has begun to melt.

IN THE GARDEN AT PONTOISE: A YOUNG
WOMAN WASHING DISHES

CAMILLE PISSARRO

Charlotte Amalie, St Thomas 1830–1903 Paris

—

Oil on canvas. 81.9 × 64.8 cm. Signed and dated, lower right: C. Pissarro / 1882.
Bought from the Spencer George Perceval Fund with a contribution from the
National Art Collections Fund, 1947. PD.53–1947

Pissarro's commitment to painting the rural life of France meant that his landscapes are generally populated, and – in the first part of his career, at least – the inhabitants are rarely depicted independently of the land from which they derived their existence.

From the early 1880s, however, he began to paint figure subjects on a large scale, and continued to explore the genre throughout the following decade. The majority of these depict female figures at work – in the fields, at the market, or in domestic surroundings – and many are painted in what has sometimes been called his 'proto-divisionist' technique, although in this painting the intermingled flecks of colour are applied with none of the rigour of neo-Impressionist theory. The textured surface and matt tones of blues and purples are found in other works of around this date, such as the *Young Peasant Woman drinking her Coffee* (1881, Art Institute of Chicago), which was described as resembling a pastel when shown at the seventh Impressionist exhibition in 1882. This scene was painted at quai Pothius, Pontoise, where Pissarro was living in 1882, before moving to Osny at the end of the year.

Pissarro's change of direction was by no means universally well received. Several critics accused him of attempting – and failing – to follow in the genre of rural figure painting initiated by Millet earlier in the century. Pissarro clearly found the comparison both irksome and curious, claiming that, as 'an old Hebrew', he had no wish to imbue his figures with the same religious overtones as Millet's peasants. Instead, his aim was to represent peasant life sincerely and without external referents; Pissarro admitted, but was suspicious of, anecdotal figure painting, opposing this sort of 'literary' painting with the 'real' painting in which he and his fellow-Impressionists were engaged. If Pissarro's shift in subject matter was intended to promote the sale of his work, his attempts were largely unsuccessful. The dealer Durand-Ruel strongly urged him to revert to his earlier 'attractive' – and sellable – landscapes; he nevertheless appears to have bought this painting directly from Pissarro for 800 francs.

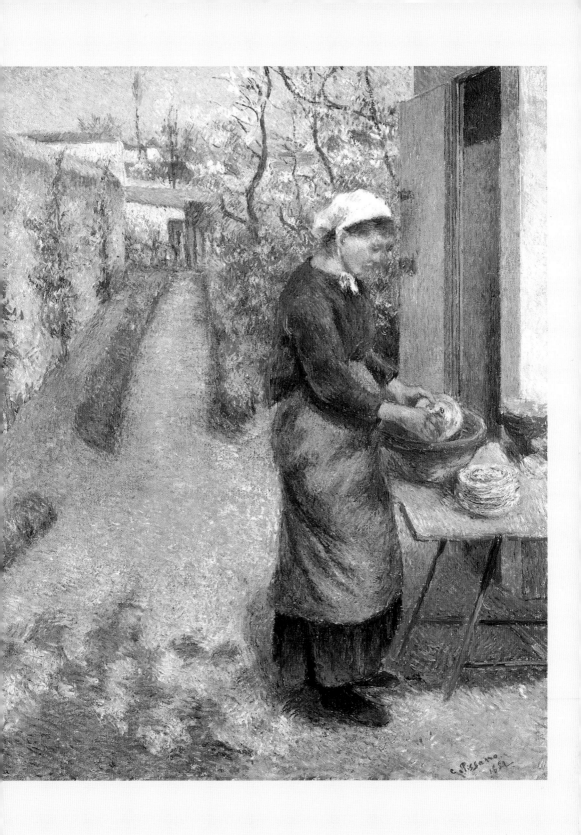

SNOWY LANDSCAPE AT ÉRAGNY, WITH AN APPLE TREE

CAMILLE PISSARRO
Charlotte Amalie, St Thomas 1830–1903 Paris

—

Oil on canvas. 38.1 × 46 cm. Signed and dated, lower right:
C. Pissarro 95. Bequeathed by the Very Revd Eric Milner White,
CBE, DSO, DD, Dean of York, 1963. PD.974–1963

Pissarro was in a position of financial instability for most of his life. In 1884, when his wife was expecting their fifth child, he looked for a house big enough to accommodate his ever-expanding family. He finally settled on a house with a large garden at Éragny-sur-Epte, near Bazincourt, two hours from Paris, which he told his son Lucien was, at 1,000 francs a month, 'superb and inexpensive'.

This view was painted from the large barn at the foot of his garden, which Pissarro converted into a studio. The orchard and surrounding countryside became the principal motifs in his paintings of the 1890s; however the fluid brushwork and use of bright, unmixed colours against the white ground distinguish it from the thicker impasto and more flecked handling of other paintings of this date. For some scholars, the surface smoothness recalls the paintings on ceramic tiles which Pissarro began to produce in 1877, although it is possible, too, that both it, and the calligraphic quality of the brush strokes, owe something to his contemporary interest in the decorative arts. In December 1895, Pissarro made several visits to the Salon de l'Art Nouveau organized by the dealer Samuel Bing at his premises in rue de Provence, which included works by Henri van der Velde, Maurice Denis and Paul Ranson as well as a group of 'decorated handkerchief boxes' made by his own son, Georges, and could not fail to have been impressed by the emphatically curvilinear, decorative style of the range of works on display. The cold greys of his earlier snow scene of Brittany (no. 43) are here replaced by the warmer tonalities of snow in sunlit conditions, the whites varying from blue-grey to mauve and peach-pink depending on the absence or presence of weak sunlight. The prominent form of the apple tree in the foreground features as something of a *leitmotif* in many of Pissarro's paintings and watercolours of Éragny, its distinctive, twisted trunk anchoring the composition throughout the seasons, whether covered in springtime blossom or skeletal and leafless in a frozen winter landscape.

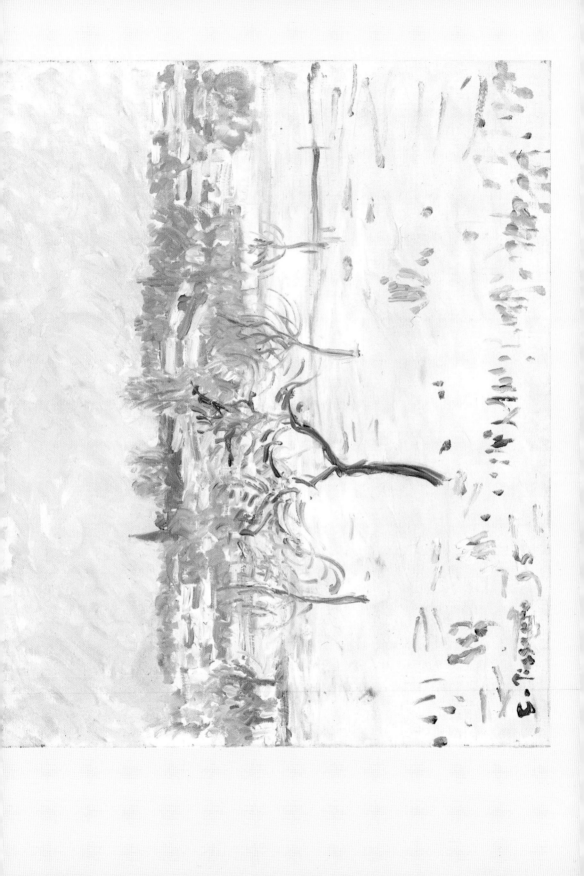

JULIEN TANGUY

CAMILLE PISSARRO
Charlotte Amalie, St Thomas 1830–1903 Paris

—

Black, red, green and blue chalk on blue paper. Watermark: JH(or N)R.
474 × 260 mm. Signed, lower left: C. Pissarro. Given by
Madame Esther Pissarro in memory of her husband,
Lucien Pissarro, 1947. PD.50–1947

Outside his immediate family, Pissarro was an infrequent portraitist, and those whom he did choose to paint or draw generally belonged to his most intimate circle of acquaintances. The identification of the sitter in this drawing as the colour merchant Julien 'Père' Tanguy (1825–94) rests on family tradition.

Tanguy was one of the most widely cherished figures of Impressionist and neo-Impressionist circles. Born near Saint-Brieuc in Brittany, he worked as a plasterer and butcher before coming to Paris in the early 1860s, where he was employed as a grinder at a colour merchant's. When he returned to Paris after serving in the Franco-Prussian war, he opened his own business in cramped premises in the rue Clauzel. This modest shop became a meeting-point for avant-garde painters in Paris, such as Gauguin, Cézanne and Van Gogh, and was an exhibition space for their work. Pissarro dealt with Tanguy from at least 1872; by 1880, although Tanguy had sold only three of his paintings, Pissarro had acquired almost 3,500 francs' worth of colours in return.

While the unconventional pose makes it difficult to compare this figure directly with other known portraits of Tanguy by Émile Bernard and Van Gogh – both painted in 1887 – the sitter's general appearance and build is broadly similar, and closely resemble written accounts of his physique. In 1908, Bernard remembered Tanguy as combining the 'granite-like' roughness of his native Brittany with an exceptional delicacy: 'his nose, like that of Socrates, was very squashed. His eyes, small and without malice, were full of emotion. [The] top of his head was slightly prominent; the lower part of his face was short and round. He was of medium build, with the strong limbs of a worker.'

This portrait is generally thought to have been drawn in the late 1880s. Earlier in the same decade, Pissarro urged his son, Lucien, to follow Holbein's example in portraiture by keeping his drawings simple and focusing on the general features of the physiognomy, so as to 'make something closer to caricature than a pretty picture'.

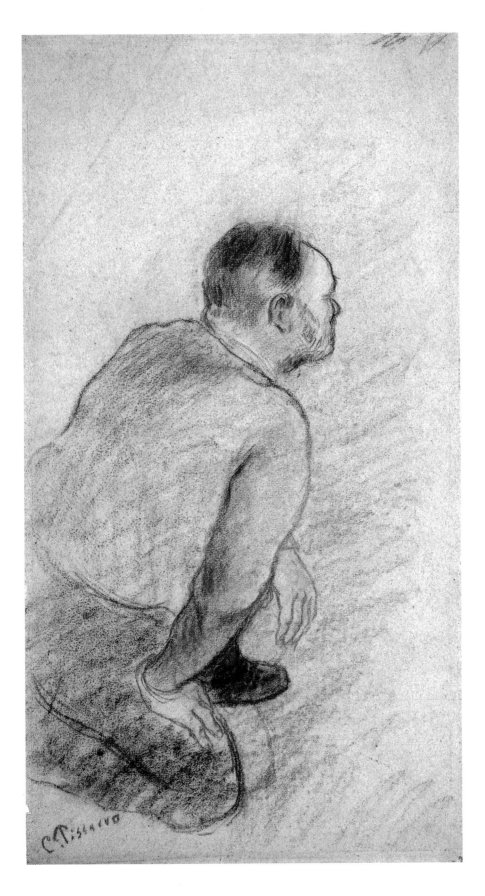

FULL-LENGTH STANDING NUDE WOMAN, VIEWED FROM BEHIND

CAMILLE PISSARRO

Charlotte Amalie, St Thomas 1830–1903 Paris

●

Black, red, pink and olive-green chalk on laid pink paper (Watermark: L. P.
[?P. L.] BAS). 478 × 243 mm. Stamped with initials in black ink, lower right:
C. P. Inscribed in black chalk with colour annotations. Given by Madame Esther
Pissarro in memory of her husband, Lucien Pissarro, 1947. PD.51–1947

Pissarro made relatively few paintings and drawings of nudes. His wife is said to have dis-approved of his working from the female nude, although for most of his life he would also have lacked the funds to employ a model to pose. Around 1894, however, partly prompted by a lengthy period of bad weather, which made landscape painting impossible, he began to produce a series of works which he described as his 'romantic prints and drawings . . . many Bathers in all sorts of poses, in landscapes of paradise'.

This study was first used for a painting of a single female nude, seen from behind, dated 1895 (Sotheby's New York, 5 November 2002, lot 58). However, the position of the left arm and right leg relate more closely to the figure on the right of his painting *The Bathers*, 1896 (Hiroshima Museum of Art), which itself recurs in a more finished painting of the same year, executed in a horizontal, rather than a vertical, compositional format (Pissarro and Venturi 1939: 940).

Pissarro used pink paper fairly extensively for pastels between 1881 and 1884, and in the 1880s also used coloured mounts and frames for the prints he exhibited at Impressionist exhibitions. In this drawing, as the colour notes suggest, he explores the contrasting tones of pinks, reds and greens, which are picked up in the Hiroshima painting in the vibrant red of the woman's buttocks and the flecks of green in the shadowed areas of her back. When Degas described Pissarro's women as 'angels on their way to market', he no doubt had in mind the working women who populate Pissarro's landscapes and market scenes; however, as this tender drawing shows, he was equally able to imbue the potentially titillating subject of the female nude with a touching and almost beatific aura of innocence and naïvety.

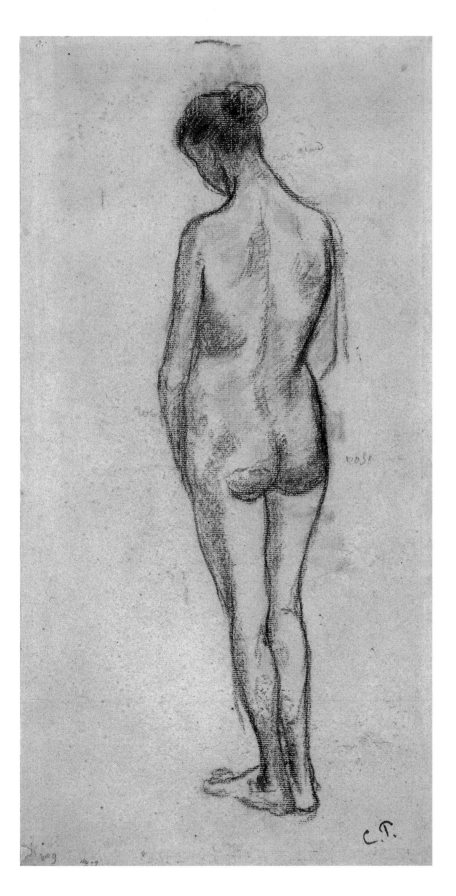

GISORS

CAMILLE PISSARRO

Charlotte Amalie, St Thomas 1830–1903 Paris

●

Watercolour with black chalk on paper. 289 × 228 mm. Signed in graphite,
lower left: C. Pissarro; inscribed and dated in watercolour, lower left:
Gisors. 84. Given by A. S. F. Gow through the National Art
Collections Fund, 1978. PD.60–1978

Pissarro used watercolour throughout his career, but took it up seriously only from the beginning of the 1880s. Initially he appears to have been attracted to the medium, at least in part for financial motives: the materials were cheaper, he wrote, and, as a technique, it offered quicker results for comparatively minimal effort. Nevertheless, he clearly also appreciated watercolour for its intrinsic aesthetic merits. In 1891 he recommended it to his son, Lucien as 'a good means to help one's memory, above all with transitory effects', and encouraged Signac to explore the medium more fully after his move to the south of France in 1892 (see no. 63). In December 1880 he told his friend Théodore Duret that he was hoping to find a lucrative alternative market for his work by producing 'serious' watercolours, although he continued to send drawings in a wide variety of other media, as well as prints, to the Impressionist exhibitions.

The market town of Gisors in Normandy is about three kilometres from Éragny, where Pissarro settled in April 1884, the year this watercolour was painted. When revisiting Gisors a few weeks earlier, Pissarro had written enthusiastically of the rich fund of pictorial subject matter which he found there and which he had overlooked on an earlier visit with his son, in particular, 'the whole wooded section of the public park, the superb forests with extraordinarily irregular terrain . . . The park with great trees and towers covered with vegetation, and a view of church spires in the distance is superb. Old streets, three little streams, filled with picturesque motifs; and the countryside is superb, too. I hastily made some watercolours'. This view shows the eleventh-century castle with its fifteenth-century bastions, and, to the left of centre, the church of Saints Gervase and Protase.

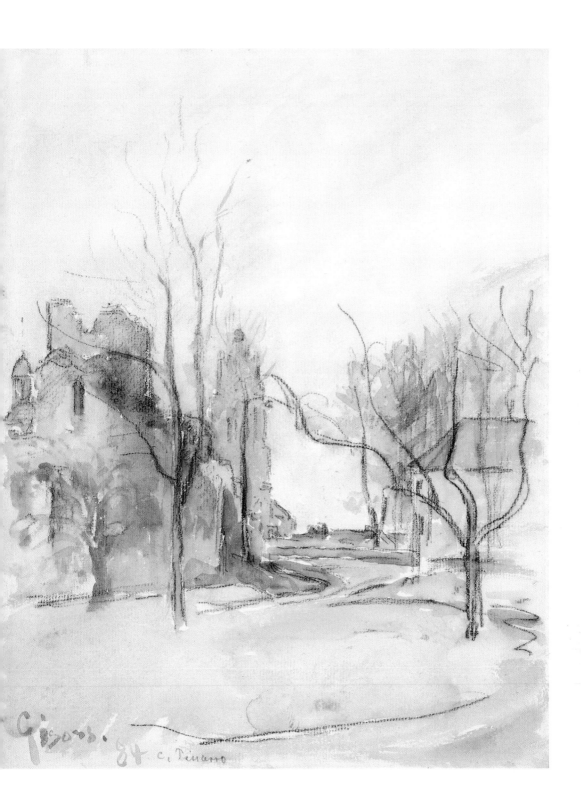

Gisors
84 c. Pissarro

ÉRAGNY

CAMILLE PISSARRO
Charlotte Amalie, St Thomas 1830–1903 Paris

—

*Watercolour over graphite on paper. 177 × 253 mm. Inscribed and dated in
graphite, lower left: 4 mars 1890 – Éragny; signed in graphite, lower right:
C. Pissarro. Bequeathed by Dr E. M. Martland, 1962, with a life interest
to Miss E. M. J. Pleister, relinquished at her death, 1982. PD.10–1982*

Pissarro made over two hundred paintings of Éragny-sur-Epte and its surrounding country-side (see no. 45), and in 1891 alone made 161 watercolours, which he organized into separate portfolios. This view looks over the meadows towards the town from a viewpoint not dissim-ilar to the snow scene he painted five years later (no. 43), although from a position that was slightly lower down and closer to the village itself.

Pissarro had settled in Éragny in the spring of 1884, and appears to have had no regrets about his decision: he told his dealer, Durand-Ruel, that his garden and the surrounding meadowland were so beautiful that he could not keep himself from painting them, and his son Lucien that he found it 'more beautiful than Compiègne. Spring's beginning, the pastures are green, the distant silhouettes are fine.' In 1892, thanks to a loan from Monet, he succeeded in buying a house and lived there for longer than anywhere else, until his death, over a decade later, at the age of 73. Pissarro's reasons for concentrating on his most immediate surroundings were as much health-related as they were a matter of aesthetic choice. From 1888 he suffered from an inflamed tear gland, which subsequently made it impossible for him to work out of doors for long periods of time.

As this watercolour shows, Pissarro lost none of his initial enthusiasm for the motif; here his interest is clearly in representing the burgeoning springtime foliage, contained within three horizontal barriers of fences and lines of trees, as it begins to obscure the distant village. The sky has lost some of the original intensity of blue, perhaps caused by fading due to damp.

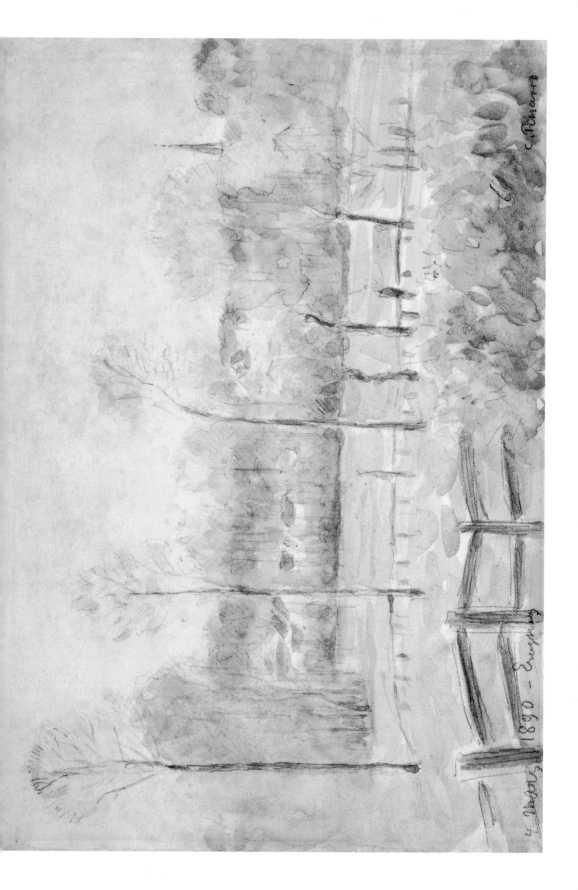

LANDSCAPE

PAUL GAUGUIN
Paris 1848–1903 Atuona, Îles Marquises

Oil on canvas. 50.5 × 81.6 cm. Signed and dated, lower right: p. gauguin. 7:73.
Given by the Very Revd Eric Milner-White, CBE, DSO, Dean of York, in devoted
memory of his mother, Annie Booth Milner-White, 1952. PD.20–1952

After spending six years at sea, Gauguin left the French Navy in April 1871, at the recommendation of his guardian, Gustave Arosa, and began to work as a stockbroker's agent, but he also painted in his spare time. He exhibited at the Salon for the first time in 1876, and in that year gave up his job in order to devote himself full-time to painting. Arosa introduced him to Pissarro, and through him he met Cézanne, whose works he greatly admired. In 1879 he accepted Pissarro and Degas's last-minute offer to contribute to the fourth Impressionist exhibition; his comparative wealth at this stage in his life also enabled him to participate in this exhibition as a lender. He subsequently exhibited with the group in 1880, and – despite tendering his resignation – in 1881, 1883 and 1886.

This is one of Gauguin's earliest known paintings. The inscription records that it was painted in September ('7' i.e. 'sept'embre) 1873, and the view probably depicts the countryside on the outskirts of Paris. At this time Gauguin was working for the stockbroker Paul Bertin, but had already begun to frequent some of the free academies in Paris. Earlier that summer he had spent his annual vacation at Arosa's country estate at Saint-Cloud, to the west of Paris, at which time, his future sister-in-law recorded in her letters, he was painting for ten hours a day on Sundays. During these visits Gauguin would also have been able to familiarize himself with Arosa's important collection of paintings, which included works by Courbet, Delacroix, Jongkind, Corot and Pissarro. Stylistically, this painting bears clear echoes of Corot in tonality and composition, however the elongated canvas (a non-standard format) and deep perspectival recession following the lines of the fields are more closely reminiscent of Pissarro's landscape, *Spring* (1872, private collection, Madrid), one of a series of four paintings representing the seasons commissioned by Arosa in 1872.

Although the painting appears to have been begun out of doors, on a canvas commercially prepared with a white ground, various corrections and changes suggest that it was subsequently completed in the studio.

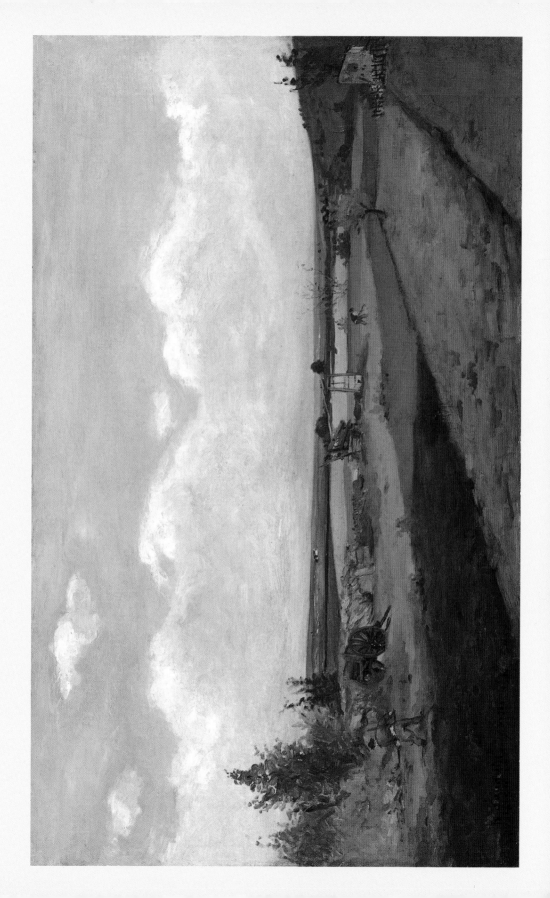

FAN DESIGN: GARDEN UNDER SNOW

PAUL GAUGUIN

Paris 1848–1903 Atuona, Îles Marquises

•

Watercolour and bodycolour over black chalk on fine linen. 242 × 525 mm.
Signed in bodycolour, centre left: P. Gauguin. Given by Professor Ronald
Pickvance (Christ's College, 1950) in memory of his wife Gina
(Georgina Rosamund, 1932–97), 2001. PD.57–2001

Like several of the Impressionist painters, Gauguin was keen to explore the compositional challenge of the idiosyncratic fan-shaped form. In fact, the Impressionist exhibition to which he first sent his work, in 1879, included a group of twenty-three fans, mainly by Degas and Pissarro, as well as five paintings and pastels by Mary Cassatt depicting fans, or women holding them; together, they created enough of an impact to lead one critic to sense the outbreak of a 'fan epidemic'.

Gauguin painted his first fan-shaped composition in 1884, and over the next eighteen years he executed more than thirty designs, mostly based on motifs that he had accumulated during his extensive travels in France, Martinique and Tahiti. His earliest designs – generally painted in gouache and watercolour on silk, or, as here, fine linen – were loosely derived from paintings or etchings by Cézanne and Pissarro in his own collection. Thereafter, his compositions drew on elements from his own oil paintings, often combining motifs culled from several different works, with varying degrees of fidelity to the original.

In this fan design, probably painted in Copenhagen in 1885, Gauguin combined features from two paintings of snow scenes, both executed some years earlier. The bare trees and buildings have been loosely adapted from those in an unpeopled landscape in the Ny Carlsberg Glyptothek, Copenhagen, which is inscribed on the frame '1879', while the two young women on the left, their positions slightly modified, appear in a painting of the same subject which is signed and dated 1883 (private collection; Wildenstein 2002:98). In 1885, Gauguin reworked these elements in a large-scale oil painting of a similar scene, now in a private collection, which previously belonged to Gauguin's brother-in-law, the Danish author Edvard Brandes (1847–1931), who was also the first owner of this fan.

A NUDE YOUTH

PAUL CÉZANNE

Aix-en-Provence 1839–1906 Paris

—

*Black chalk with stump on laid paper. Watermark: Crown shield with
an M. 485 × 307 mm (irregular). Verso: inscribed in graphite in Louis Clarke's
hand; rough sketch – possibly an offset – of the same model as on recto. Bequeathed
by Louis C. G. Clarke, 1960; received 1961. PD.54–1961*

Cézanne took his first lessons in drawing at the municipal school in his home town of
Aix-en-Provence between 1857 and 1861, mostly with Joseph Gilbert, the director of the school
and curator of the Musée des Beaux-Arts. After moving to Paris in April 1861, he prepared
for the entrance examination of the École des Beaux-Arts by studying in the mornings at the
Atelier Suisse, an open studio located in the Île de la Cité, which was run by a pupil of Jacques-
Louis David known as 'père' Suisse. For a fixed sum a month to cover the model and upkeep,
students were able to work in a variety of drawing media, either directly from the model or on
a composition of their own invention. Although Cézanne failed to gain entry to the École des
Beaux-Arts the following year, he continued to study at the Atelier Suisse, where he became
friendly with Pissarro, Armand Guillaumin and Antoine Guillemet, through whom he met
Monet, Sisley, Frédéric Bazille and Renoir.

This vigorous drawing was probably executed during one of the sessions at the Atelier
Suisse sometime between 1863 and 1865. Pissarro, who remained one of Cézanne's most
loyal friends, recorded meeting this 'strange Provençal' as early as 1863, at which time his
drawings from life were, he later wrote, 'ridiculed by all the talentless' among his fellow
students. Certainly, the almost chiselled outline deviates from the controlled, fluent drawing
of the nude which was encouraged by traditional academic teaching; however, as Pissarro
noted, they show a kinship with the rippling contours of Veronese's nude studies, even
if Cézanne's massive muscular form lacks the Venetian master's quick-silver lightness of
touch.

Comparison with paintings such as *The Abduction* (no. 53) show how well his studies of
the human form served him in his early figure compositions.

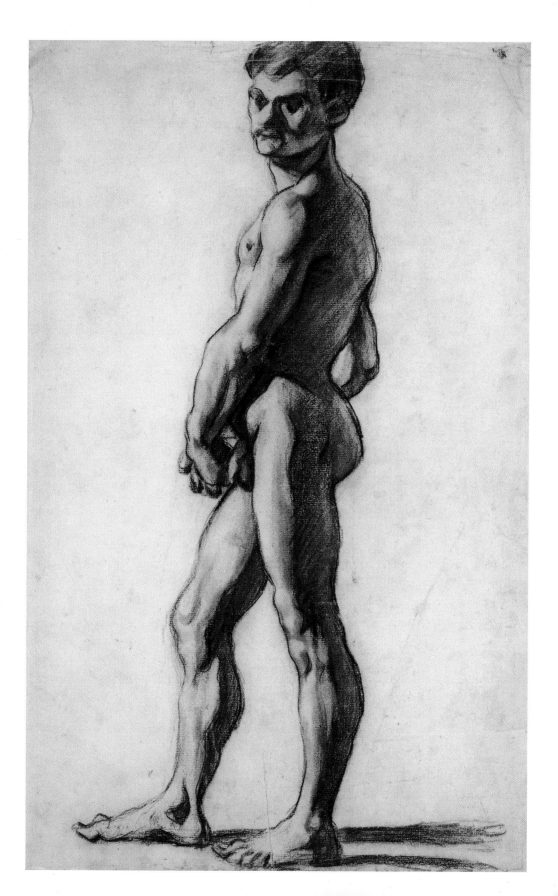

THE ABDUCTION

PAUL CÉZANNE

Aix-en-Provence 1839–1906 Paris

—

Oil on canvas. 88 × 170 cm. Signed and dated, lower left: 1867 Cézanne.
The Provost and Fellows of King's College (Keynes Collection)

At the beginning of 1867, Cézanne told his friend Émile Zola – to whom this painting once belonged – of his wish to paint something 'immense'. While not especially large in scale, this powerful early work is monumental in its conception of the human figure and highly dramatic in its representation of violent sexual conflict. Themes of violence, eroticism and romantic fantasy are common in Cézanne's work around 1866–71; his friend Joachim Gasquet later remembered him during this period as being 'frightening, full of hallucinations, almost bestial in a kind of suffering divinity . . . He was in despair because he could not satisfy himself'.

The subject of this painting – executed in Zola's home in the Batignolles quarter of Paris – has been much discussed, however it is now generally agreed that it is drawn from Ovid's *Metamorphoses*. Although one account identifies the figures as Hercules and Alcestis, it is also possible that the scene represents the abduction of Proserpine by Pluto, as recounted in Book V of the *Metamorphoses*. If this is the case, the landscape setting would represent Mount Etna in Sicily (although it is also reminiscent of Mont Saint-Victoire in the artist's native Provence), the garment the female figure is trailing would be the apron in which Proserpine had been gathering flowers, and the two distant figures – who anticipate the theme of the bathers which came to dominate Cézanne's later work – would be the water nymphs Cyane and Arethusa, the latter, literally dissolving into the lake with grief, modelled on the pining figure of Echo in Poussin's *Echo and Narcissus* (1629–30) in the Louvre.

Few of Cézanne's paintings speak so eloquently of his debt to Delacroix, whose own representations of themes of abduction may well have inspired this painting. His free reworking of a theme from antiquity reveals the extent of his ambition at this stage in his career, and was, perhaps, also intended, as a number of scholars have suggested, to prove to his sceptical friend Zola that the tradition of history painting had not yet died.

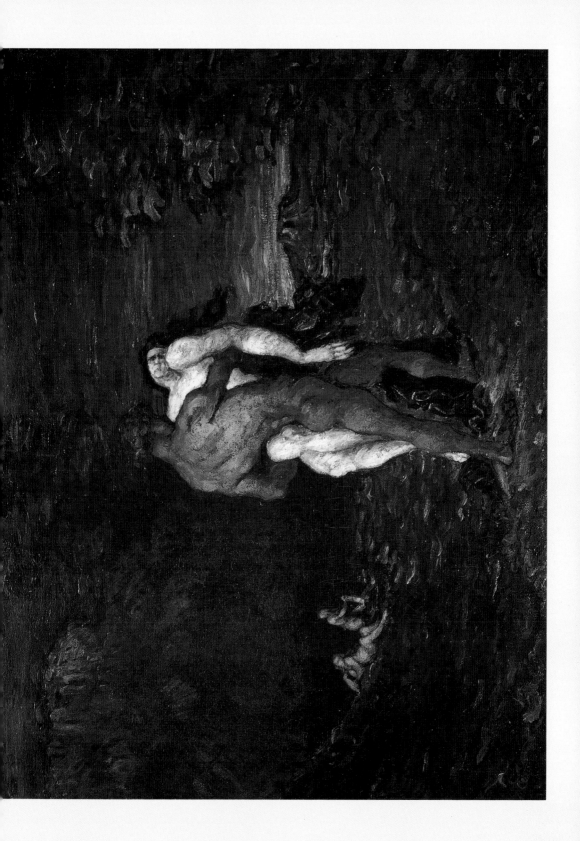

UNCLE DOMINIQUE

PAUL CÉZANNE
Aix-en-Provence 1839–1906 Paris

—

*Oil on canvas. 39 × 30.5 cm. The Provost and Fellows
of King's College (Keynes Collection)*

Cézanne maintained that 'the goal of all art [is] the human face'. He painted portraits through-out his career, and over fifty self-portraits in various media between around 1866 and 1906.

During the early 1860s he drew his models mainly from his close circle of family and friends, and called on none more consistently than his maternal uncle, Dominique Aubert, a local bailiff whom he painted on at least ten occasions and in a variety of different costumes and guises – as a lawyer, a monk, or wearing a night cap. Another of Cézanne's models at this time, his close friend, the writer Antoine Valabrègue, was impressed by Aubert's tenacity in modelling so frequently: 'Fortunately I only posed for one day. The uncle is asked to serve as a model more often. Every afternoon a portrait of him appears, while Guillemet belabours it with terrible jokes' (to Émile Zola, November 1866). He also complained that Cézanne was 'a horrible painter as regards the poses he gives people . . . Every time he paints one of his friends, it seems as though he were revenging himself on him for some hidden injury'.

All of Cézanne's portraits of his uncle – for the most part head or head-and-shoulder studies – were painted between October 1866 and January 1867, when Cézanne returned to Paris. Each is thought to have been executed in a single afternoon session, and is painted in strong, contrasting colours, vigorously applied with a palette knife and illuminated by a single, intense light source. This energetic manipulation of the paint surface – in part inspired by his knowledge of Courbet's work – was described by Valabrègue as 'mason's painting', painted with a 'pistol' as well as a 'knife', and by Cézanne himself as his *manière couillarde* ('ballsy manner').

Aubert's strong, swarthy features – his bulbous nose, in particular – marvellously withstand both the force of Cézanne's characterization and the violence of his paint application.

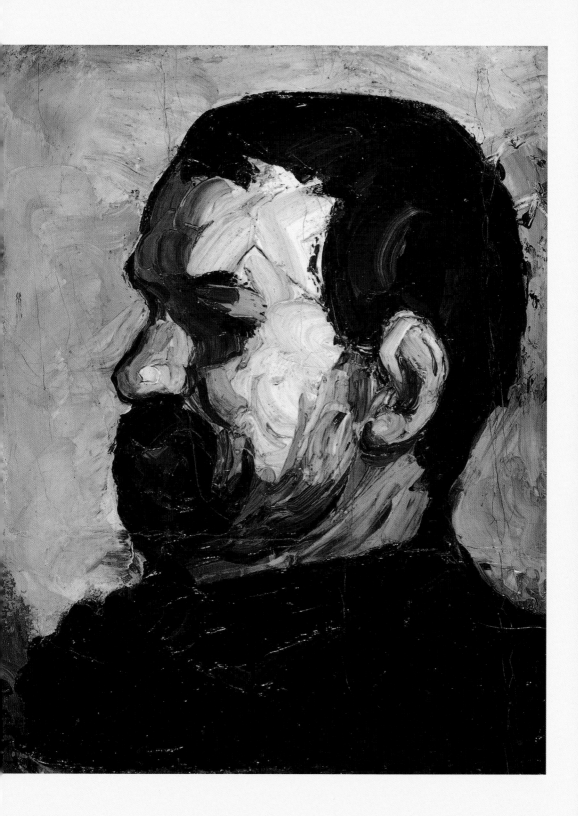

STILL LIFE WITH APPLES

PAUL CÉZANNE

Aix-en-Provence 1839–1906 Paris

—

Oil on canvas. 19 × 27 cm.
The Provost and Fellows of King's College (Keynes Collection)

Traditionally considered the lowest genre in the academic hierarchy of subject matter, still life painting occupied a significant, even iconic, role in Cézanne's work. A notoriously slow worker, inanimate forms provided him with the perfect opportunity to explore and refine his method of building up a composition by using a sequence of ordered brush strokes, applied in parallel, square touches.

This painting was executed sometime between 1877, when Cézanne exhibited for the second and last time with the Impressionist painters, and 1878, when he returned to live in Provence. In contrast to fellow-Impressionists such as Monet, whose goal was to register as swiftly and accurately as possible the initial impression – or, to use Cézanne's preferred term, *sensation* – of a subject on canvas, Cézanne's own approach was more considered and analytical. In his still-life paintings, in particular, he took great trouble organizing the constituent compositional elements, so that here the roundness of an individual apple is understood as much through its relationship to adjacent forms as through its structured internal modelling.

Cézanne himself claimed that he planned to conquer Paris with an apple, and his paintings of this single fruit have in fact proved to be among his most admired works. His near contemporary, Thadée Natanson, described him as 'the painter of apples . . . It is he who has given them shining dresses of red and yellow, who has made tiles of reflecting light on their skins, who has encompassed in a loving stroke their rotundity, and has created from them a delicious definitive image'. Bought by Degas for 100 francs in January 1896, this painting was acquired in Paris by John Maynard Keynes at the sale of the contents of Degas's studio in March 1918 (see introduction p. 5). It is one of the most celebrated of all his still lifes, and, through Keynes's friendship with the painter and writer Roger Fry and with the circle of Bloomsbury writers, came to be crucial in the dissemination of knowledge of Cézanne's work in England.

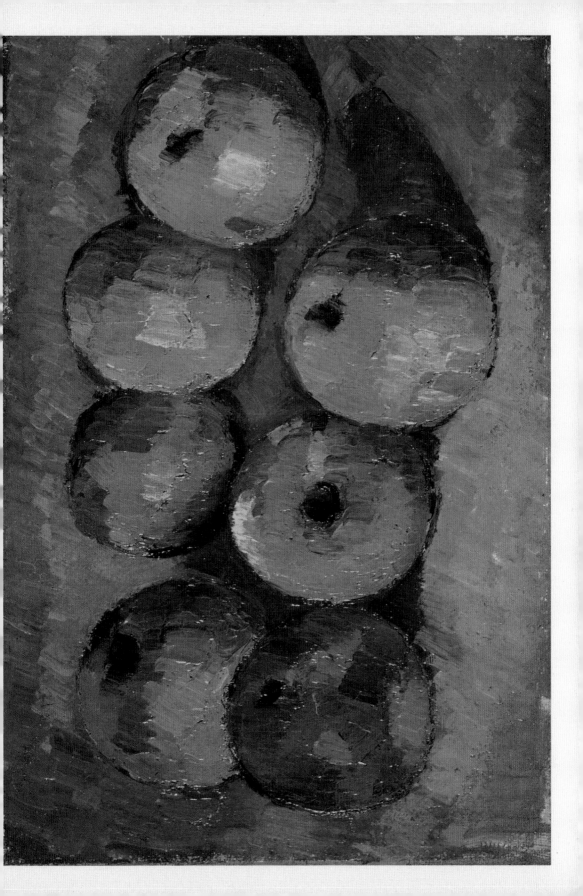

LANDSCAPE: THE FOREST CLEARING

PAUL CÉZANNE

Aix-en-Provence 1839–1906 Paris

-

*Oil on canvas. 62.2 × 51.5 cm. Bequeathed
by Frank Hindley Smith, 1939. No. 2381*

Cézanne began to paint landscapes in the early 1870s, working in Marseilles and later at Pontoise and Auvers. Initially, his style of landscape painting was influenced by Pissarro, whom he had met in Paris a decade earlier and with whom he worked in the mid-1870s and early 1880s. Even in this so-called 'Impressionist' phase, however, Cézanne was less concerned with capturing the transient or the ephemeral in nature, than with stabilizing the sensations he experienced before the landscape, believing that 'Art must give us a taste of nature's eternity'. His many paintings of trees, as thickets, groves, forests and avenues, provided him with an ideal means to achieve the permanency which he sought in nature, their naturally constructive forms imposing a strong internal structure on the composition, while filtering more transient elements such as light in order to create patches of colour that assumed an equally assertive role in the composition and chromatic modelling of form.

This landscape was for some time thought to have been painted between 1882 and 1885, but current opinion favours a significantly later dating of around 1900–04, since, influenced by his experience of working in watercolour, Cézanne used a similar form of overlapping brushwork extensively in other oil paintings around this date. The location of the view remains uncertain.

Left unfinished, notably in parts of the sky and forest floor, the painting conveys a remarkable sense of luminosity and vibrancy through the contrast of warm and cool tones, the rhythmic brushwork and the patches of bare canvas, which became positive elements in the reading of the composition.

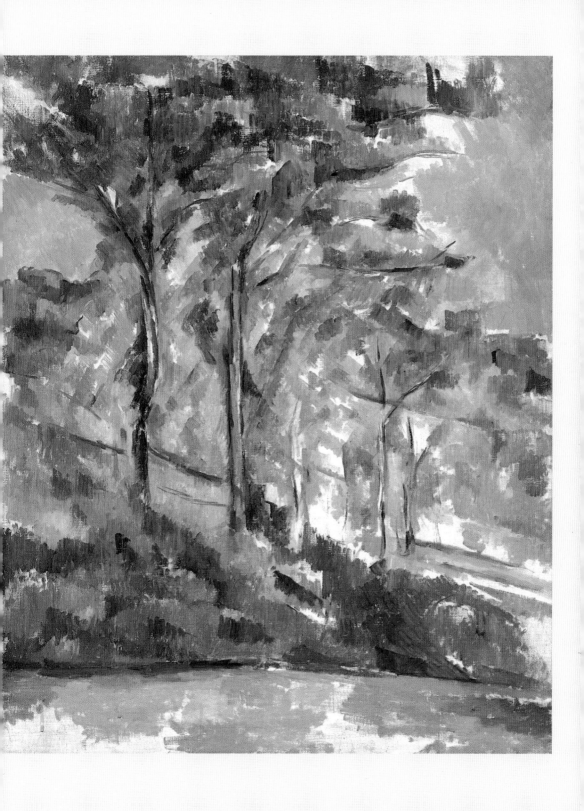

THE WOODS, AIX-EN-PROVENCE

PAUL CÉZANNE

Aix-en-Provence 1839–1906 Paris

◆

Watercolour over light graphite markings on paper. 466 × 300 mm.
Bequeathed by Captain Stanley William Sykes, OBE, MC, 1966. PD.6–1966

Cézanne worked in watercolour throughout his career. His friend Antoine Marion remembered his very first efforts in the medium, made in the late 1860s using a box of colours his father had found in a consignment of old metal, as being 'particularly remarkable, their colouration is amazing, and they produce a strange effect of which I did not think watercolours capable'. The three he showed at the Impressionist exhibition of 1877 – one a still life, the others landscapes, entitled simply 'impressions from nature' – failed even to be mentioned by reviewers; thereafter, he exhibited them only rarely, until 1895, when a group was included in the major retrospective exhibition of his work held by the dealer Ambroise Vollard in Paris. The exact content of the exhibition is uncertain, but the enthusiastic response of Cézanne's fellow-painters to his watercolours is amply recorded. Monet, Renoir, Gauguin and Cézanne's long-standing friend, Pissarro, all expressed the greatest admiration for their fluency, assurance and understated daring, while Degas, who bought a watercolour of pears at the Vollard exhibition, was said by Pissarro to have been 'passionate about Cézanne's sketches'.

The landscape has been dated 1887–90. Although on one level the highly diluted colour washes and large areas of blank paper give the impression of spontaneity and improvisation, closer inspection shows that Cézanne has worked with patience and deliberation. He exploits to the full the fluidity and transparency of the medium, while at the same time maintaining rigorous control over its application, carefully placing individual patches of colour and leaving them to dry before adding adjacent areas of wash, frequently in unrelated colour registers.

For Signac, Cézanne was the painter who had best understood watercolour as the medium of suggestion and equivalence: his skies and landscapes were, he wrote, 'magnified onto a poor sheet of paper, barely covered with twenty touches of watercolour – twenty certainties – twenty victories'.

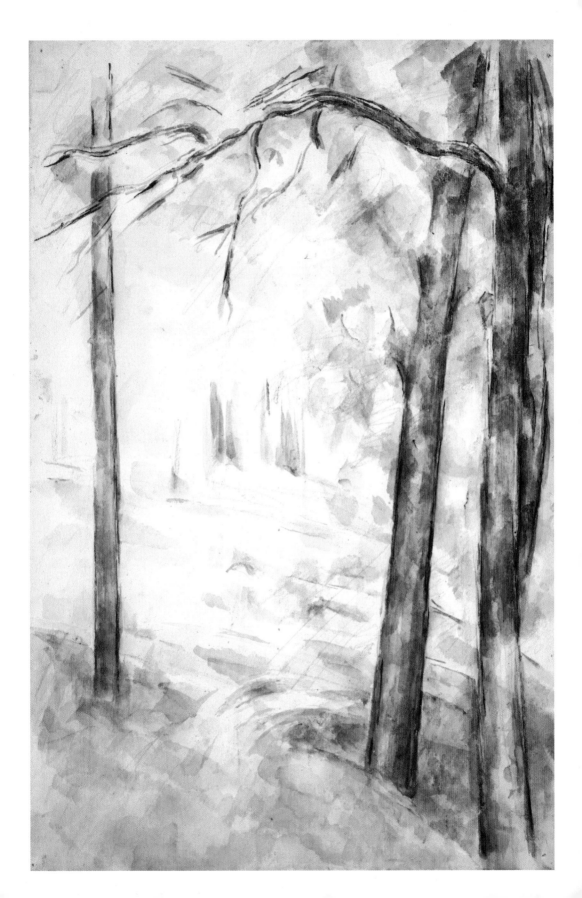

FLOWERS IN A VASE

PAUL CÉZANNE
Aix-en-Provence 1839–1906 Paris

—

Graphite and watercolour on paper
Verso of PD.6–1966 (no. 57)

Cézanne devoted increasing attention to watercolour from 1885. This still life, executed on the *verso* of no. 57, is generally considered to have been painted slightly earlier than the watercolour on the other side of the sheet. Rewald has assigned it a date of 1885–88, possibly later, thus revising by up to a decade an earlier dating of 1895 and 1900.

The precision with which Cézanne juxtaposed barely tinted colour washes, often in square, block-like brush strokes, has led many authors to compare his watercolours to the polished surfaces of cut, coloured glass. In his biography of 1927, Roger Fry described him as trying to represent in his watercolours 'the phenomenon of crystallization in a saturated solution', indicating 'the nuclei whence the crystallization was destined to radiate through the solution'. Here, these qualities of transparency and refraction are enhanced by the areas of paper that have been left untouched, which appear as separate planes of insistent whiteness. Cézanne uses a glass vase to colour the interplay of the two transparent substances – glass and water – while leaving the notionally more solid and highly coloured forms of the bouquet unexplained, but for the slightest graphic underdrawing.

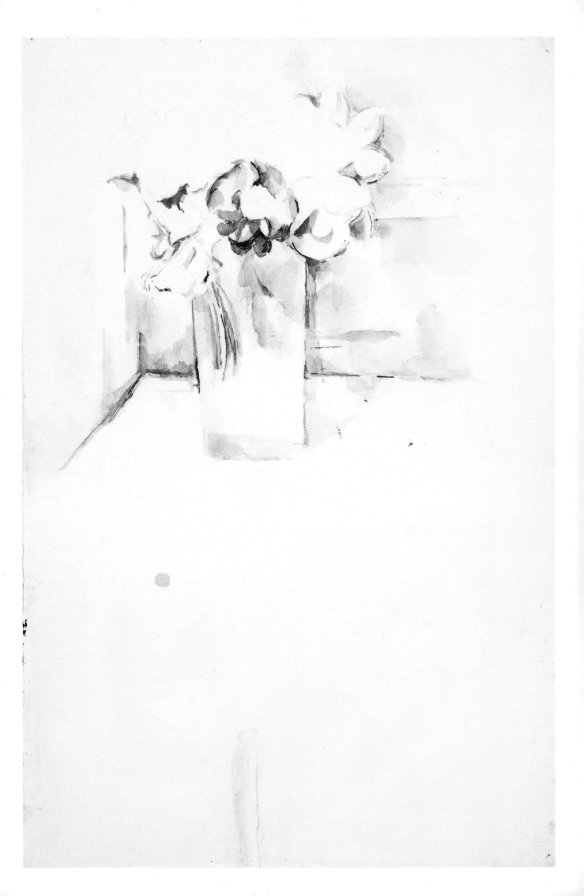

THE RUE SAINT-VINCENT, PARIS, IN SPRING

GEORGES-PIERRE SEURAT
Paris 1859–1891 Paris

◦

Oil on panel. 24.8 × 15.4 cm.
Given by Captain Stanley William Sykes, OBE, MC, 1948. PD.1–1948

Seurat began his artistic career in 1876, studying first in a municipal drawing school and then, from 1878 to 1881, in the studio of Henri Lehmann at the École des Beaux-Arts. Between 1881 and 1883 he devoted much of his time to drawing, mainly in black – possibly conté – crayon; his first work accepted for exhibition at the Salon in 1883, was in fact a portrait drawing in this medium of his friend, the painter Aman-Jean. After considerable canvassing by Pissarro, he was invited to exhibit with the Impressionists in 1886, his only showing with the group (see no. 60).

This study of an unpopulated street scene in leafy Montmartre was painted around 1884. At the end of the previous year Seurat had made another painting of the street under snow (private collection, de Hauke 1961: 70), and both his sensitivity to the changing moods of nature and his high-toned palette reveal the growing impact of the Impressionist painters on his work. By far the majority of Seurat's paintings are executed on wooden supports, of dimensions similar to this panel. These '*croquetons*' ('sketchettes'), as Seurat called them – which he regularly exhibited in groups with his larger canvas paintings – are sometimes prepared with a white paint ground, but more often the wood is left in its natural state, as it is here, to create an intermediary warm brown tonality, his only preparation in this case being to scratch the wooden surface so as to give it 'tooth'.

The rue Saint-Vincent was a popular haunt of artists in the nineteenth century; Corot painted it as a quiet village street much earlier in the century (Musée des Beaux-Arts, Lyons), and – perhaps inspired by his example – Pissarro made an etching of it in 1865. Rodolphe Darzens, a friend of Seurat, described it as being 'adored by painters, so picturesque and so sad', a melancholic image which was captured by Aristide Bruand in a piquant music hall refrain of the 1890s, about Rose, a beautiful orphan from Montmartre, who found love in the rue Saint-Vincent, but who died, an adolescent bride, on her wedding day.

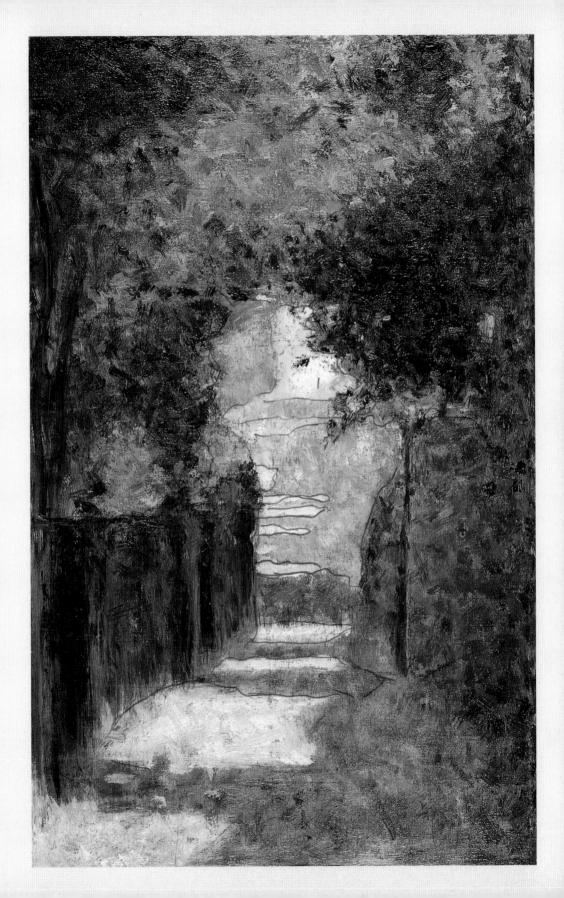

STUDY FOR A SUNDAY ON THE ISLAND OF LA GRANDE JATTE: COUPLE WALKING

GEORGES-PIERRE SEURAT
Paris 1859–1891 Paris

—

*Oil on canvas, with squaring up in conté crayon. 81 × 65 cm. The Provost
and Fellows of King's College (Keynes Collection)*

This is one of only three large-scale preliminary studies in oil on canvas which Seurat used to prepare his painting, *A Sunday on the Island of la Grande Jatte* (1884–86; Art Institute of Chicago), first publicly exhibited at the eighth and last Impressionist exhibition in May 1886. The finished painting earned him instant notoriety, due to its subject, scale (3.5 metres wide), and, especially, the *pointilliste* – or, to use Seurat's preferred term, *chromoluministe* – technique in which it was painted. This method of applying small touches of unmixed pigment in optical mixtures of complementary, or similar, colours has generally been considered to demonstrate his interest in scientific chromatic theory, derived mainly from his reading of Charles Blanc's *Grammaire des arts de dessin* (1867), although it may also have been influenced by Blanc's notions of ideal colour and moral harmony.

In this sketch Seurat establishes the broad chromatic structure of the composition, and through it the passages of light and shade, applying a criss-cross stroke which he described as *balayé* (literally: 'swept on'), over a commercially prepared white ground. Visible under the paint layer is a grid drawn in conté crayon, which corresponds, with only a few differences, to that which structures the compositional sketch for the painting in the Metropolitan Museum of Art in New York. This enables Seurat not only to establish the disposition of the figures and pictorial planes, but also to maintain the rigidity in the figures' poses, which is key to his artistic objectives.

The scene represents, in simplest terms, a group of contemporary Parisians at leisure on an island in the Seine. The identity of the elegant couple that dominates this sketch has been much disputed. The fact that, in the finished painting, the woman holds onto a leash of a long-tailed monkey has led to the suggestion that she represents a prostitute (*singesse*, in contemporary Parisian slang), perched on the arm of her client. More recently, however, it has been argued that Seurat's intention was, rather, to parody the stiff *cant britannique* and fashionable pretensions of these promenaders, solemnly engaged on a quintessentially bourgeois Sunday afternoon activity.

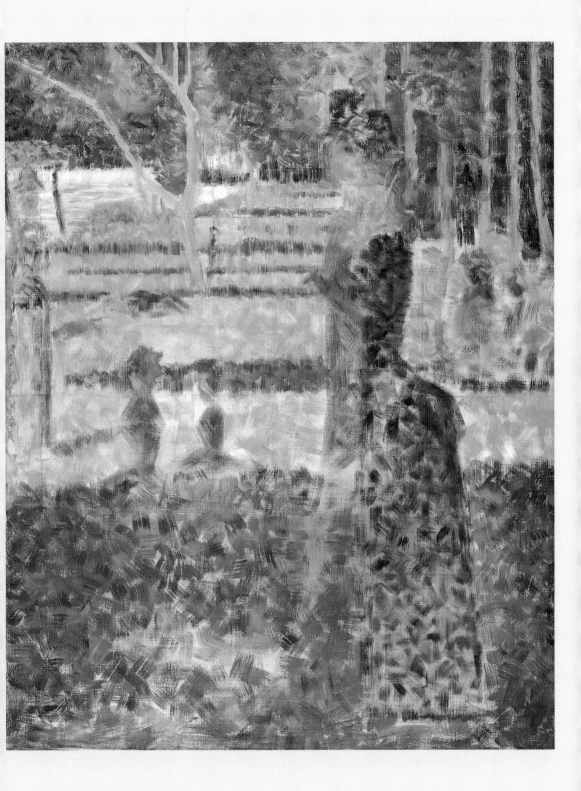

THE ENTRY TO THE PORT, PORTRIEUX

PAUL SIGNAC

Paris 1863–1935 Paris

—

Oil on panel. 15.1 × 25.1 cm. Signed, lower left: P signac (the 'P' and the 'S'
in monogram). Given by the Very Revd Eric Milner-White,
Dean of York, CBE, DSO, DD, 1959. PD.9–1959

Signac's first paintings were of Paris and its suburbs, but from the late 1880s he began to paint many of the ports that he sailed to along the French coast. Like Boudin, Brittany was one of his favourite haunts; he visited Saint-Brieuc and the Emerald Coast in the summer of 1884, and returned there on several occasions until 1892, when he decided to seek out warmer, and dryer, Mediterranean climes and moved his base to Saint-Tropez.

This view is of the harbour at Portrieux-la-Houle, a small Breton village on the Channel coast where Signac worked between June and September 1888, in the company of his wife, Berthe, and the 'second' on his boat, his friend, the writer Jean Ajalbert. It is one of six studies in oils on panel and nine finished canvases that he made during his stay, which represent the port from a number of different viewpoints. Many of the paintings bear the subtitle '*opus*', referring to a chronological list of his works which Signac kept between 1887 and 1902; this study, '*opus* 188', is one of four relating to the painting *Portrieux: La Houle* (Stuttgart, Staatsgalerie, 1888), which Françoise Cachin has recently suggested Signac swopped for a copy of Alfred Robaut's catalogue of Delacroix's paintings, published three years earlier (2000: no. 172). Like the others, this 'prelude' is executed in a flat, rectangular brush stroke, leaving areas of the reddish-brown wooden panel blank to create a warm background tone, just as Seurat did in many of his oil sketches (see no. 59).

The painting formerly belonged to Seurat. The two artists first met at an inaugural meeting of the Société des Artistes Indépendants in 1884, but fell out after the publication of an article by Arsène Alexandre in 1888 in which Seurat was credited with the invention of *pointillisme*, an achievement for which Signac felt he deserved recognition. Despite this, Signac, with Félix Fénéon and Maximilien Luce, was entrusted with the execution of Seurat's estate on the latter's untimely death in 1891.

FISHING BOATS

PAUL SIGNAC

Paris 1863–1935 Paris

◆

Charcoal, watercolour and traces of bodycolour on paper. 202 × 278 mm.
Signed in black chalk, lower right: P. Signac; inscribed with colour notes.
Bequeathed by Frank Hindley Smith, 1939. No. 2413

An enthusiastic sailor, Signac was familiar with much of the French coastline, and, from the late 1880s, many of his paintings and watercolours depict ports and vessels in full sail or at anchor. Between 1929 and 1931 he exploited his navigational experience to the full, in order to carry out a project of his own conception to paint all the one hundred ports of France in watercolour, an enterprise which he was able to carry out thanks to the financial support of his friend, Gaston Lévy (1893–1977), a private collector who was co-founder of the Monoprix supermarket chain.

Largely self-taught as a painter in oils, Signac developed a highly personal watercolour style, based on Pissarro's initial advice, and subsequently on the example of his three touch-stones, the 'idealist' Turner, the 'realist' Jongkind and the 'analyst' Cézanne. He increasingly valued watercolour for the freedom which it offered from the laborious constraints of oil painting, and in the last fifteen years of his life gave up the latter completely. While he had evidently studied a number of published treatises on watercolour painting, notably John Ruskin's *Modern Painters* (1843–60) and *The Elements of Drawings* (1857), his own approach, as outlined in a chapter of his monograph on Jongkind of 1927, was to question any such proscriptive texts. The use of gouache or bodycolour, for example, was, he noted, 'forbidden in the watercolourist's religion' and was spurned by dealers, who considered it to sully the purity of the transparent medium. Instead, he believed that a technique should be considered on its merits and used without hesitation if the compositional circumstances dictated. In this port-scape 'notation' he consciously rejects any such technical prejudices by adding bodycolour to heighten the white of the sails and to pick out the tiny figure of the sailor in the foreground.

The precise location remains to be identified.

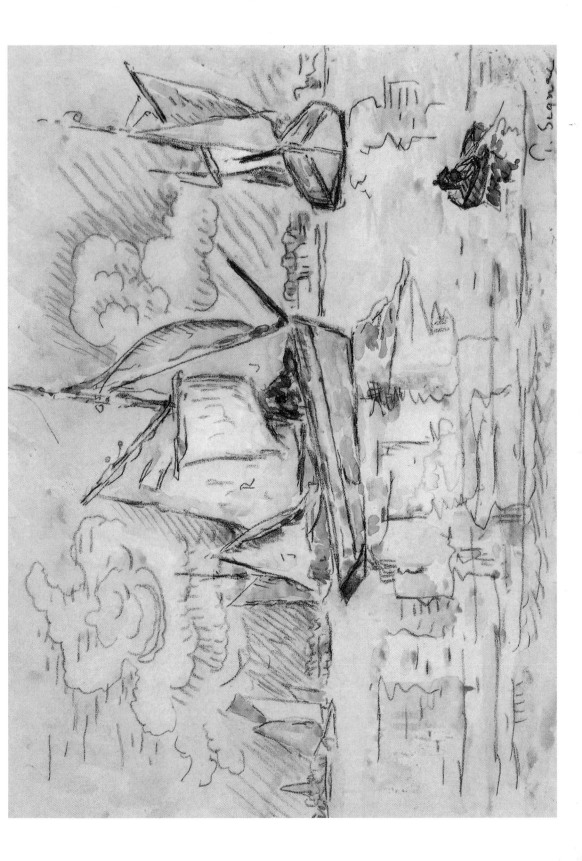

VIERVILLE, CALVADOS

PAUL SIGNAC

Paris 1863–1935 Paris

Bodycolour and watercolour on paper, laid down. 231 × 294 mm.
Signed and dated, lower right: P. Signac / Vierville (1913). Bequeathed
by Frank Hindley Smith, 1939. No. 2412

During the 1880s, Signac worked almost exclusively in oil, but, prompted by Pissarro, whom he first met in 1885, he began to work more regularly in watercolour after moving to the south of France in 1892. Four years earlier, Pissarro had recommended the medium to him, as being a 'very valuable and practical method of notation. One can take notes in a few minutes which would be impossible by any other means – the fluidity of a sky, certain translucent light effects and a host of little details which cannot be achieved by long labour, as effects are fleeting.'

Like Pissarro, Signac initially referred to his watercolours as 'notations', and exhibited them as such for the first time at the Hôtel Brébant in Paris at the end of 1892. Three years later, however, he evolved a personal technique that he described as 'watercolour heightened with pen and ink', in which the colour washes are articulated by a highly decorative, calligraphic line, reminiscent of the drawings of Van Gogh.

Although he did not regret his decision to move to the southern coast, he quickly realized that its climate, while otherwise agreeable, presented a challenge to watercolour painters in search of 'effects'. Compared to the more variable weather conditions in northern Europe, he wrote, the artist's principal source of meteorological drama in the Mediterranean were the sunsets. Not surprisingly, two of the three watercolour painters whom he cited as particular influences were English (Turner, whose watercolours he first saw on a visit to London in 1898) and Dutch (Jongkind, to whom he later devoted a monograph). On the whole, Signac's watercolours are painted in a brilliant palette of primary colours (compare nos. 62 and 64).

In this watercolour, however, painted at Vierville, Calvados, in 1913, the cooler blues and greens convey something of the more verdant Norman countryside, an area of France which Degas, some years earlier, considered to be one of the most 'English' parts of France.

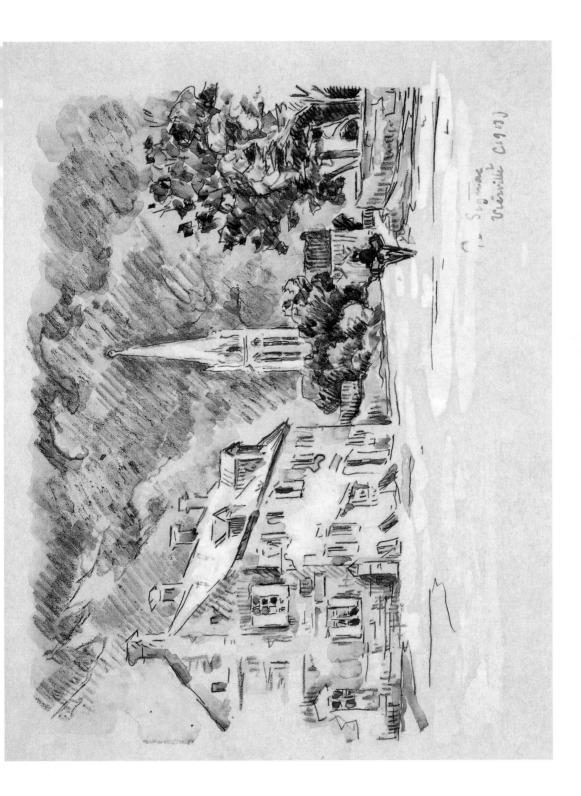

P. Signac
Vréville (1923)

SAINT-TROPEZ

PAUL SIGNAC
Paris 1863–1935 Paris

•

Charcoal, watercolour and bodycolour on paper. 249 × 325 mm.
Signed and dated, lower left: Paul Signac | 1914. Bequeathed
by Sir Hamilton Kerr, 1974; received 1975. PD.98–1975

Saint-Tropez was a town of key significance in Signac's life. He first sailed into the port on his yacht *Olympia* in May 1892, while on a visit to his friend Henri Cross at nearby Le Lavandou, and decided to set up his base there later the same year, renting a house on the beach until 1897, when he bought a house of his own. He remained there until 1913, making occasional trips to Holland (1896), London (1898, 1909) and Venice (1904, 1908), but in that year moved to Antibes with his partner, Jeanne. In the time he spent there, he made a vast number of watercolours of the town: his *carnet d'opus* (see no. 61) for the years 1899–1900 and 1901 alone lists over four hundred.

Signac's method of working in watercolour neccessarily differed greatly from the divisionist style he adopted for his oil paintings, the liquid medium being unsuited to the direct juxtaposition of strong complementary tones. On the other hand, its sheer unpredictability could be used to advantage, by applying small *tâches* (blotches) of wash, often leaving blank white paper around and between them, so as to increase the resonance and vibrancy of the colour: a yellow, or an orange, in particular, he wrote, could lose all its force if the eye was unable to see it against a background of white. For this, he advocated a smooth paper, rather than the stiff, absorbent papers generally recommended for watercolour, so as to allow the wash to settle in 'little ponds', which would assume a variety of different forms as they dried. He then worked up these freely applied touches with black chalk so as to give definition and structure, especially – as is the case in this watercolour – to architectural elements or details of shipping. Like Ruskin, whom he admired (even if he considered him *un peu bavard*, 'a little long-winded'), Signac abhorred the practice of scratching the white paper ground in order to introduce highlights, and of sponging over the wash to create texture: 'Let us leave these unappetising practices to pedicurists.'

REFERENCES AND FURTHER READING

A Day in the Country. Impressionism and the French Landscape, exhibition catalogue, Los Angeles, County Museum of Art, Art Institute of Chicago and Paris, Grand Palais, 1984

Alexandre, Arsène, *A.-F. Cals, ou le bonheur de peindre*, Paris, 1900

Armstrong, Carol, *Odd Man Out. Readings of the Work and Reputation of Edgar Degas*, Chicago and London, 1991

Bailly-Herzberg, Janine, ed., *Correspondance de Camille Pissarro*, 4 vols., Paris, 1980, 1986, 1988, 1989

Bernard, Emile, *Julien Tanguy, dit le 'Père Tanguy'*, Caen, 1990

Berson, Ruth, *The New Painting. Impressionism 1874–1986, Documentation*, vol. I, *Reviews*, vol. II, *Exhibited Works*, San Francisco, 1996

Boggs, Jean Sutherland, *Degas at the Races*, exhibition catalogue, Washington, National Gallery of Art, 1998

Boggs, Jean Sutherland et al., *Degas*, exhibition catalogue, Paris, Grand Palais, Ottawa, National Gallery of Canada and New York, Metropolitan Museum, 1988

Browse, Lillian, *Degas Dancers*, London, 1949

Cachin, Françoise, *Signac. Catalogue raisonné de l'œuvre peinte*, Paris, 2000

Cahen, Gustave, *Eugène Boudin, sa vie et son œuvre*, Paris, H. Floury, 1900

Callen, Anthea, *The Art of Impressionism: Painting Technique and the Making of Modernity*, New Haven and London, 2000

Cariou, André, *Impressionistes et néo-impressionistes en Bretagne*, exhibition catalogue, Rennes, 1999

Cooper, Douglas, *The Courtauld Collection: A Catalogue and Introduction*, London, 1954

Distel, Anne, *Les collectionneurs des Impressionistes amateurs et marchands*, Düdingen/Guin, 1989

Dumas, Ann, Ives, Colta et al., *The Private Collection of Edgar Degas*, exhibition catalogue, New York, Metropolitan Museum of Art, 1997

Durand-Ruel Godfroy [sic], Caroline, collected and annotated, *Correspondance de Renoir et Durand-Ruel, 1881–1906*, Lausanne, 1995

Ferretti-Bocquillon, Marina, *Signac aquarelliste*, Paris, 2001

Flint, Kate, ed., *The Impressionists in England. The Critical Reception*, London, Boston, Melbourne and Henley, 1984

Fry, Roger, *Cézanne. A Study in his Development*, London, 1927

Gimpel, René, *Diary of an Art Dealer* (1963), London, 1992

Gowing, Lawrence, *Cézanne: The Early Years, 1858–1872*, exhibition catalogue, London, Royal Academy of Arts, Paris, Musée d'Orsay, and Washington, National Gallery of Art, 1988–9

Guérin, Marcel, ed., *Degas Letters*, Oxford, 1947

Halévy, Daniel, *My Friend Degas*, translated and edited with notes by Mina Curtiss, London, 1966

Hauke, César-M. de, *Seurat et son œuvre*, Paris, 1961

Herbert, Robert L., *Impressionism; Art, Leisure and Parisian Society*, New Haven and London, 1988

Herbert, Robert L., *Seurat Drawings and Paintings*, New Haven and London, 2001

House, John, Distel, Anne *et al.*, *Renoir*, exhibition catalogue, London, Arts Council of Great Britain, 1985

House, John *et al.*, *Monet. Nature into Art*, New Haven and London, 1989

House, John *et al.*, *Impressionism for England. Samuel Courtauld as a patron and collector*, exhibition catalogue, Courtauld Institute of Art, New Haven and London, 1994.

Janis, Eugenia Parry, *Degas Monotypes*, Cambridge, Mass., 1968

Jean-Aubry, G., *Eugène Boudin d'après les documents inédits. L'homme et l'œuvre*, Paris, 1922

Kendall, Richard, *Degas Beyond Impressionism*, exhibition catalogue, London, National Gallery, New Haven and London, 1996

Kendall, Richard, *Degas Intime*, Ordrupgaard, 1994

Kendall, Richard, *Degas Landscapes*, exhibition catalogue, New Haven and London, 1993

Kendall, Richard, *Degas and the Little Dancer*, New Haven and London, 1998

Klein, Jacques-Silvain, *La Normandie. Berceau de l'Impressionisme*, Rennes, 1999

Lemoisne, Paul-André, *Degas et son œuvre*, 4 vols., Paris, 1946–9

Lewis, Mary Tompkins, *Cézanne*, London, 2000

Lipton, Eunice, *Looking into Degas: Uneasy Images of Women and Modern Life*, Berkeley, 1986

Lloyd, Christopher and Thomson, Richard, *Impressionist Drawings from British Public and Private Collections*, exhibition catalogue, London, Arts Council of Great Britain, 1986

Loyrette, Henri, *Degas*, Paris, 1991

Manoeuvre, Laurent, *Eugène Boudin Dessins*, with preface by Roseline Bacou, Paris, 1991

Merlhès, V., ed., *Correspondance de Paul Gauguin*, 3 vols. Vol. 1, *1873–1888*, Paris, 1984

Moffett, Charles, *et al.*, *The New Painting. Impressionism 1874–1886*, Oxford, 1986

Paris, Bibliothèque Nationale de France, and Malibu, J. P. Getty Museum, *Degas photographe*, exhibition catalogue, 1999

Paris, Grand Palais, Amsterdam, Van Gogh Museum and New York, Metropolitan Museum, *Signac*, exhibition catalogue, 2001

Paris, Grand Palais, and New York, Metropolitan Museum of Art, *Georges Seurat, 1859–1891*, exhibition catalogue, 1992

Pickvance, Ronald, *Degas*, exhibition catalogue, Martigny, Fondation Giannada, 1993

Pickvance, Ronald, *Gauguin*, exhibition catalogue, Martigny, Fondation Giannada, 1998

Pissarro, Joachim, *Camille Pissarro*, London, 1993

Pissarro, Ludovic Rodo and Venturi, Lionello, *Camille Pissarro. Son art – son œuvre*, 2 vols., Paris, 1939

Reff, Théodore, *The Notebooks of Edgar Degas*, 2 vols., Oxford, 1976

Rewald, John, *Cézanne. A Biography*, London, 1986

Rewald, John, *The History of Impressionism* (1946), 4th, revised edn, 1973; reprinted London, 1980

Rewald, John, *Paul Cézanne: The Watercolours – A Catalogue Raisonnné*, Boston and London, 1983

Rewald, John, ed., *Camille Pissarro. Letters to his Son, Lucien* (1943), New York, 1995

Rewald, John, with Walter Feilchenfeldt and Jayne Warman, *The Paintings of Paul Cézanne: A Catalogue Raisonné*, 2 vols., New York, 1996

Rouart, Denis, *Degas la recherche de sa technique*, Paris, 1945

Shackelford, George, *Degas. The Dancers*, New York, 1984

Shiff, Richard, *Cézanne and the End of Impressionism*, Chicago and London, 1984

Shone, Richard, *Sisley*, New York, 1992

Signac, Paul, *Jongkind*, Paris, 1927

Smith, Paul, *Impressionism: Beneath the Surface*, London, 1995

Smith, Paul, *Seurat and the Avant-Garde*, New Haven and London, 1997

Spate, Virginia, *The Colour of Time: Claude Monet*, London, 1992

Stevens, MaryAnne, ed., *Alfred Sisley*, exhibition catalogue, Lyons, Musée des Beaux-Arts, 2002

Stuckey, Charles F., with the assistance of Sophia Shaw, *Claude Monet, 1840–1926*, exhibition catalogue, Art Institute of Chicago, 1995

Thomson, Richard, *Camille Pissarro. Impressionism, Landscape and Rural Labour*, New Amsterdam, and New York, 1990

Thomson, Richard, *The Private Degas*, London, 1987

Tucker, Paul Hayes, *Claude Monet. Life and Art*, New Haven and London, 1995

Tucker, Paul Hayes, *Monet in the '90s: The Series Paintings*, exhibition catalogue, Boston, Museum of Fine Arts, and London, Royal Academy of Arts, 1989

Valéry, Paul, *Degas, Danse, Dessin*, Paris, 1938

Verdi, Richard, *Cézanne and Poussin: The Classical Vision of the Landscape*, exhibition catalogue, Edinburgh, National Galleries of Scotland, 1990

Vienna, Kunstforum and Zurich, Kunsthaus, *Cézanne Finished and Unfinished*, exhibition catalogue, 2000

Vollard, Ambrose, *Recollections of a Picture Dealer* (1936), New York, 1978

Vollard, Ambrose, *Renoir: An Intimate Record* (1925), London, 1990

Wildenstein, Daniel, *Claude Monet: catalogue raisonné*, 4 vols., Cologne, 1996

Wildenstein, Daniel, *Gauguin: A Savage in The Making. Catalogue Raisonné of the Paintings* (1873–1888), Milan, 2002